HAUNTED
MEMPHIS

HAUNTED MEMPHIS

LAURA CUNNINGHAM

Haunted America

Published by Haunted America
A division of The History Press
Charleston, SC 29403
www.historypress.net

Copyright © 2009 by Laura Cunningham
All rights reserved

*All images courtesy of the Memphis and Shelby County Room, Memphis Public Library and
Information Center, unless otherwise stated.*

First published 2009

Manufactured in the United States

ISBN 978.1.59629.712.8

Library of Congress Cataloging-in-Publication Data

Cunningham, Laura.
Haunted Memphis / Laura Cunningham.
p. cm.
Includes bibliographical references and index.
ISBN 978-1-59629-712-8 (alk. paper)
1. Ghosts--Tennessee--Memphis. 2. Haunted places--Tennessee--Memphis. I.
Title.
BF1472.U6C86 2009
133.109768'19--dc22
2009026207

For Dick, Carolyn, Joyce and Eli

CONTENTS

ACKNOWLEDGEMENTS

There are several individuals or institutions I would like to thank for the assistance they provided me with while working on this book.

I wish to thank my parents, Jim and Lela Cunningham, and my sister, Anna Edmondson, for providing me with the unconditional support I needed, not just for this book but throughout all aspects of life. I would also like to thank my family for watching over my spirited two-year-old son, Eli Morrison. Without that assistance, this book might never have been completed.

I would also like to thank Wade Murphy, Brent Armour, Corey Cochran, Leigh Rast and Dr. Jonathan Weems. Thank you all for having such contagious excitement for me. Thank you for your encouragement and for believing in me.

I would also like to thank the staff of the history department at the Memphis Public Library and Information Center. Their knowledge and assistance in locating information proved invaluable during this experience. I would especially like to thank Gina Cordell for suggesting that I might be interested in writing about Memphis history.

I would also like to thank G. Wayne Dowdy, author and archivist for the Memphis and Shelby County Room. Thank you for helping to arrange this book and assisting with any question I had. Your encouragement to preserve this form of local folklore became the driving force for this project.

INTRODUCTION

In December 2008 I decided I was going to write a book about Memphis ghost stories. I had been contemplating the idea for quite some time, but only then did I begin thinking that it was something I might actually be able to do. I began telling people I was going to write a book, and the reactions were mixed. I spent several years working in downtown museums and also conducting historic walking tours throughout Memphis. Through these experiences, I began collecting local ghost stories and sharing this information with others. Each time I was asked to tell a ghost story, I became more convinced that these stories were an important form of folklore and needed to be preserved.

Memphians are naturally curious about these familiar locations, and ghost stories have an enduring appeal. The stories I have selected for this book have been included because of their significance in Memphis history. These stories have either been documented in some form or shared by word of mouth. With any type of folklore, each story has some variation in the details. These stories are legends—stories that were originally told as fact and have been embellished with each retelling.

As a historian, my job was to research and evaluate hundreds of documents and official records that pertain to the people and places involved in these stories. As a writer, my job was to relay this collection of Memphis ghost lore in what I hope is an entertaining and informative format.

INTRODUCTION

I cannot prove or disprove the existence of ghosts in Memphis, nor is it my intention to do so. My ultimate purpose is simply to preserve these stories, which otherwise may have been lost.

PINK LIZZIE, THE GHOST OF BRINKLEY FEMALE COLLEGE

While most Memphians are familiar with Mary, the Orpheum ghost, or Mollie, who haunts the Woodruff-Fontaine House, Lizzie, the ghost of Brinkley Female College, is a distant memory in Memphis history. While Mary's and Mollie's stories are repeated year after year at Halloween, neither can compare to the attention given to Lizzie. In 1871, Memphians became so terrified of Pink Lizzie that the city came to a halt after dark. After Lizzie's first appearance, stores closed early because men and women were afraid to go out alone at night. Bartenders took advantage of the fear by serving Ghost Cocktails. Even visitors to Memphis became fearful and shortened their stays in Memphis because of the ghost.

The Brinkley Female College was a school for young girls located on a portion of South Fifth Street lined with large mansions and stately yards. Today, the same section of street is occupied by railroad buildings and warehouses. The Wurzburg Brothers, Inc. warehouse now sits on the exact setting of the most sensational ghost story in Memphis history.

Between 1855 and 1859, Colonel W.J. Davie built a grand, two-story mansion with six tall Ionic columns in front. His estate stood on a slight hill, protected by an iron gate. Soon after the Civil War, the house was transformed into Brinkley Female College. Allegedly, the school acquired a reputation as an odd place almost immediately after it opened its doors. The house already had a reputation for being haunted via the school's founder, who was rumored to have gone bankrupt and insane.

On Tuesday, February 21, 1871, Clara Robertson sat at the piano practicing her music lesson in one of the upper rooms at the Brinkley Female College. Unlike most of her fellow classmates, twelve-year-old Clara was a day student who lived nearby at 261 De Soto Street, known today as Fourth Street, between Vance and Elliot. Clara was an intelligent girl with blonde hair and bright blue eyes.

As she practiced, a horrifying vision suddenly appeared before her eyes. The apparition looked to be an eight-year-old girl but with sunken, matte eyes and an emaciated face. Her withered body was clothed in a filthy, torn pink dress, partially coated in what appeared to be a thick, slimy layer of mold. She wore rusty shoes with mildewed stockings. Startled, young Clara stared in horror and gasped as she realized that this was no ordinary young girl. The child standing in front of her was transparent.

Clara screamed, ran into the adjoining bedroom and jumped into bed with a girl who was ill. Clara stared as the specter drifted across the room toward her and placed her hand on the pillow next to Clara's head. Clara buried herself under the covers and attempted to wave the ghost away. A few minutes later, the ghost left the room. Terrified, Clara ran down the hall to her fellow classmates to report what she had just witnessed. Of course, no one believed her, and she left for home in tears from all the teasing that her classmates had given her. When Clara returned to school Wednesday morning, nothing out of the ordinary occurred. Clara became more confident that the incident from the day before was just a silly prank played by her fellow students.

On Thursday, Clara was with two other students in the music room when she heard the sound of water splashing to the floor. The girls turned to see the skeletal little girl standing in the middle of the room. While Clara saw the girl distinctly, reports vary as to what her two friends actually saw, if anything. The girls fled from the room and were once again met with ridicule from the other students. According to the daily newspaper, the *Memphis Appeal*, when the ghost appeared again, Clara and the others girls ran screaming down the stairs to one of their teachers, Miss Jackie Boone. The girls brought Miss Boone back to the room where they had seen the transparent little girl. However, in a letter to the newspaper, Miss

Pink Lizzie, the Ghost of Brinkley Female College

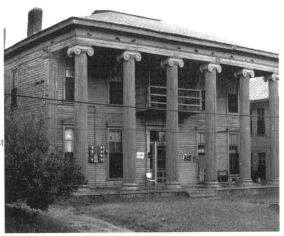

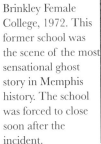
Brinkley Female College, 1972. This former school was the scene of the most sensational ghost story in Memphis history. The school was forced to close soon after the incident.

Boone denied ever returning to the room to see a ghost. When they opened the door to the music room, the ghost pointed a skeletal finger in a southward direction and began to speak.

The ghost told Clara that some valuable items were buried fifty yards from the house and that she wanted her to find them for her own use. As soon as she finished speaking these words, the ghost disappeared through the garret door. This time, none of the girls ridiculed Clara. The students were terrified.

The following morning, Clara's father, J.C. Robertson, paid a visit to Mr. Meredith, principal of Brinkley Female College. The two men agreed that the situation needed to be thoroughly investigated. Mr. Robertson was concerned for the well-being of his daughter, while Mr. Meredith thought that someone was out to ruin the reputation of his school. On Thursday, one week after the first visit from the ghost, Clara was sent into the schoolyard while Mr. Meredith assembled the other students and began questioning them. While in the yard, the little spirit appeared once again in front of Clara. Before she could let out a scream, the ghost said "Don't be alarmed Clara. My name is Lizzie. I will not hurt you." The ghostly little girl began to describe how the school property belonged to her family and how the current owners had obtained it illegally. All of her family members were now dead, and she

needed someone to undue the wrong committed against them. Lizzie wanted Clara to obtain the papers and other valuable items that she previously mentioned were buried in the yard and use these to claim possession of the property. Lizzie warned her that unless Clara did as she asked, Lizzie would "never do good to or for any one." When Clara told everyone about the ghost in the yard, several of her classmates went home frightened and sick. Clara did not go to school the next day, telling her parents that she'd rather die than return.

Clara's father was a prominent Memphis lawyer. Through his legal work, he had become acquainted with Mrs. Nourse, a reported spiritual medium. Mr. Robertson turned to Mrs. Nourse for help with his daughter.

Mrs. Nourse held a séance at the Robertson home, with several neighbors in attendance. While seated at the table, it soon became apparent that something had taken control over Clara. At first, she sat slumped and lifeless, but soon she began slowly moving her arms. Her arms began flailing faster and faster, so much so that her parents had to restrain her from hurting herself. As soon as she calmed down, Mrs. Nourse handed her a pencil and placed paper on the table. Clara began to write, illegible at first, but the words became clearer. She filled several pages, recalling the events of the past week. In the beginning, she wrote her name as Lizzie Davidson but corrected it to Lizzie Davie. Attendees at the séance began asking her questions, and she would immediately write her reply.

Lizzie, through Clara, revealed that the hidden valuables included one set of gold jewelry, a diamond necklace, several thousand dollars in coins and the title papers to the home. She also revealed that the items were buried under the tree stump on which she appeared to Clara in the schoolyard. Several men who attended the séance went and visited the school. After talking with the students and realizing that they all believed Clara's story, they decided to dig under the stump to see if any valuables could be located.

As word of the ghost story spread around Memphis, so did an interest in spiritualism. Spiritual mediums started holding nightly séances at Cochran Hall on North Main Street. Techniques such as table tipping, slate writing, bell ringing and tambourine banging

were used to communicate with spirits, which included a Native American maiden, a Union drummer boy and an Aztec chief. Clara attended these séances, further communicating with Lizzie through slate writing.

Mr. and Mrs. Meredith agreed to the digging of the schoolyard because they knew that this ordeal would never end until the stump was removed. As word began to spread throughout Memphis, people came from all over to watch the dig. Even though the police were brought in to help control the crowd, hundreds of people still managed to gain access to the schoolyard to watch. While the digging was going on, Mr. Robertson conducted an interview with the *Memphis Daily Avalanche*. He dismissed any notion that his daughter was involved in spiritualism and assured the reporter that his daughter was being truthful and his family had never experienced anything like this before.

The men digging soon discovered a layer of bricks, more of which were found after the tree stump was completely removed. The following morning, Clara was playing in her backyard when Lizzie appeared again. This time, the ghost demanded to know why Clara herself was not looking for the valuables. Before disappearing, she told Clara that she had to find them for herself. Clara immediately ran inside and told her family what happened. They decided that she should go to the school immediately. Her neighbor, Mrs. Franklin, escorted her to the school, where the excavation was continuing. It was suggested to Clara that she should call on Lizzie for further instructions on where to dig. Clara reluctantly agreed and Lizzie again appeared, though Clara was the only person to see her. Lizzie again told Clara that she should be the only person to dig for the valuables. As soon as Clara stepped into the hole, she fainted. After she was revived, she claimed to have seen a jar containing the valuables. Mrs. Nourse was brought back to the Robertson home for another séance.

During the séance, Lizzie was told that Clara was not able to dig and asked if Clara's father could dig in her place. Lizzie agreed that Mr. Robertson could dig, but once recovered, the jar could not be opened for sixty days. Mr. Robertson, Mrs. Nourse and several other men returned to the school and began to dig again.

Within an hour, Mr. Robertson found a large, moldy glass jar, at least twelve inches tall and ten inches wide. Several bags and a large envelope could be seen inside. Staying true to the agreement made with Lizzie, the jar was not opened, and Mr. Robertson hid it in the safest place that he could find.

Due to the enormous amount of stress that Clara had been through, her family thought it best for her to visit relatives out of town for the next sixty days. It was decided that the jar would be opened at the Greenlaw Opera House, located at the southwest corner of Union Avenue and Second Street. The public could purchase tickets for one dollar, with half the proceeds going to Clara on account of her "tribulations" and the other half going to the Church Home, an orphanage operated by Episcopalians. However, Bishop Charles Todd Quintard quickly let everyone know that he would not accept any money associated with a ghost.

The public opening never took place. One night, Mr. Robertson was entertaining visitors when he heard a noise outside his home. When he did not immediately return, his guests went outside and found him unconscious and bleeding profusely from the head. Four men had attacked him at gunpoint, demanding to know the location of the jar. He took them to the jar's hiding place—hanging from a rope on the seat in the outhouse.

Although Clara claimed that spirits contacted her in another séance, providing her with the location of the jar and a description and names of the thieves who stole it, the jar was never recovered.

Very little is known regarding what happened to Clara Robertson. A schoolmate, Lula Franklin, who later became Mrs. Robert Vance, was one of Clara's closest friends at school and was often at her side when Clara saw the ghostly vision. When Mrs. Vance retold the ghost story to family members, she mentioned that Clara became a changed girl after the ghost incident and soon drifted apart from her friends.

In 1939, the *Commercial Appeal* rekindled the ghost story in a series of articles published around Halloween. Several Memphians wrote in to the paper sharing their memories of the ghost story and of Clara. Mrs. Frank Gray reported that after the ghost scare, Clara lived next door to her on Adams Avenue. She claimed that between 1871 and 1876, Clara began to practice spiritualism at her home on

Adams Avenue. Clara used the technique of slate writing to receive messages. Another woman wrote to the paper to report that she had heard Clara went on to become the second wife of a spiritualist whose first wife's ghost "would return at night and kick her out of bed." A reliable source wrote to the paper and explained that in 1876 eighteen-year-old Clara married a wealthy seventy-two-year-old widower. The couple attended the Philadelphia Centennial Exposition on their honeymoon. Clara and her husband had several children, and Clara eventually died of tuberculosis. Clara may have possibly moved to Vanndale, Arkansas. Those who had contact with Clara mentioned that she had received letters about the ghost story from President Grant and Queen Victoria.

The ghost scare caused Brinkley Female College to close. Mr. Meredith went on to open the Meredith Female College at another location, which lasted three years before closing. Colonel Brinkley soon found that it was impossible to find a tenant for his haunted home. Fearful that it would be destroyed by vagrants, Brinkley offered to let the family across the street live in the home rent free in exchange for maintaining the property. In 1939, Mrs. Delcie Schmidt reported living in the home with her father, Mr. Corn, who took care of the property. She still had in her possession a mirror frame from the old mansion, rumored to have been broken by the ghost during one of her visits to the school. After living in the house for two years, the family was forced to move when a northern gentleman came to Memphis and offered to rent the house. Colonel Brinkley soon discovered that the man was actually using the home to hold spiritualistic séances, and he asked him to leave. The Corn family moved back in to the mansion and continued to live there for several years.

Eventually, the house was divided into apartments for railroad workers before becoming tenement housing. One story claimed that when Lizzie's ghost disappeared it retreated to the cupola of the house. In 1939, caretaker Reverend G.W. Thompson reported that years earlier, a strong wind came and blew the cupola away, leaving the rest of the house untouched.

Paper manufacturer Wurzburg Brothers Inc., purchased the property to expand its nearby facilities by building a warehouse. Reginal Wurzburg, owner of the company, remembered hearing the ghost

stories. He noted that the owners of the old house had trouble renting the apartments because of the ghost stories surrounding it. After his company bought the old home, it moved the residents to homes of their choice in other parts of town—before the building was dismantled.

In July 1972, workers began dismantling the old Brinkley College. Jim Williams, a local businessman, purchased the house and planned to reconstruct it on land that he owned outside Jonesboro, Arkansas. In the years after the warehouse was built at the site, contractors working at night felt the presence of some type of spirit. They heard rustling noises and watched in horror as papers flew off the shelves. They have also felt drastic temperature changes throughout the building. Many parapsychologists believe that it is very common for a ghost associated with a particular building to inhabit later structures occupying the same site.

What makes Clara Robertson's story so fascinating is the notion that if Clara's ghost story was not true, Miss Robertson played the most successful practical joke in Memphis history. In 1871, people who knew the Davie family came forward and verified the information that Clara gave as accurate. Lizzie Davie died in the home in 1861. People who attended her funeral remembered the little girl being buried in a pink dress with strawberry stains and pink slippers. Her family dressed her in the outfit because it was her favorite dress.

Several people also remembered a chancery suit concerning the grounds on which the school stood; they recalled a scandal surrounding the case, and only the grounds were involved. Colonel Davie built his home from 1856 to 1859. In 1860, he executed a title bond to R.C. Brinkley to secure a loan for stock in the Memphis and Charleston Railroad Company, valued at $30,000. Davie was to repay the value in either stock or cash at the end of four years. However, during the Civil War the railroad was operated by the military, making the stock temporarily worthless to either of the men. Brinkley foreclosed on the mortgage, but Davie sold him the home "for the amount due Brinkley and the further sum of $15,000." Perhaps Colonel Davie did pay back his loan and Brinkley still took the house. We may never know how exactly Lizzie Davie felt her family had been cheated.

THE EDUCATED GHOSTS

THE HIGBEE SCHOOL FOR GIRLS

At the corner of Beale and Lauderdale Streets, there once stood one of the finest female boarding schools in the entire mid-South. The Higbee School for Girls was originally located in the Colonel Robertson Topp Mansion, built in 1841 and located at 565 Beale Street.

The twenty-room home was built in 1841 by builder and owner Colonel Robertson Topp. Born to wealthy and aristocratic parents, Topp received his early education under a private tutor in Davidson County, Tennessee. At the age of sixteen, he became a law apprentice, and in 1831, at age twenty-three, he moved to Memphis, becoming one of the first lawyers in the city. Within six years, Topp made enough money to acquire a large tract of land in South Memphis, valued at $50,000. Originally, the property on Beale Street extended back to Linden and as far east as Orleans.

Colonel Topp was a founder of South Memphis, a separate city located directly south of Memphis, in the area of present-day Beale Street. Topp was also interested in politics, serving two terms in the state legislature. While attending a ball in Nashville, given in honor of the legislature, Topp met Miss Elizabeth Vance, a member of another prominent Memphis family. The two were married in 1837. After the couple's return to Memphis, they began the work of their new mansion on Beale.

Builders completed the lavish home in three years. An artist from New Orleans was brought in to paint frescoes, and a landscape

architect from St. Louis came to design the garden. Although he never served in politics again after his term in the legislature, Topp remained the leader of the Whig party in Memphis until the start of the Civil War. He also served as president of the Memphis & Ohio Railroad.

Although he opposed the South's secession, Topp renounced his political party and joined the Confederacy when Tennessee seceded. By the end of the war, he was all but ruined financially. His property had been seized for debt, and hundreds of slaves he had once owned, which represented thousands of dollars, were gone. With what little of his money he had left, Topp began to purchase thousands of bales of cotton throughout the southern states, storing them in warehouses. The federal government soon seized all cotton, claiming that it was owed to the North. This left Topp completely ruined financially. He spent the last remaining years of his life in Washington trying to recover the fortune he felt had been stolen.

Miss Jennie M. Higbee arrived from New Jersey soon after the Civil War. After opening a small school and serving as principal of the local high school, Miss Higbee purchased the Topp Mansion in 1880 and opened a finishing school. The Higbee School for Girls lured the daughters of prominent Memphians and other students from the area. In 1892, the school had grown to three hundred students, twenty-three faculty members and five lecturers.

Eventually, a new brick building was constructed, and the mansion became a dormitory. The school closed in 1914, and the building remained vacant until 1920. As the last occupant, the Labor Temple used the facility from 1924 until the 1970s.

In the 1930s, a caretaker for the Labor Temple who occupied the old mansion claimed that if ghosts do exist in the old home, they don't bother him. However, when the building was used as a school and dormitory, there were frequent sightings of a woman in a white dress seen on the staircase.

Allegedly, a young bride was walking down the circular staircase on her wedding day. She somehow slipped and fell, landing dead in the arms of her beloved. Her ghost has been on the stairs several times. The students often claimed to hear the sounds of footsteps going up and down the stairs on regular basis. A teacher at the school, Mrs. Annie Mayhew Fitzpatrick, made a significant

The Higbee School, founded in 1880, was located at Beale Street and Lauderdale on the former Topp estate.

discovery while investigating the ghost. One day she heard a tapping at the stairs, as if someone was walking up and down. When she went to the staircase to investigate, she noticed that the tapping noise was being made by a painting flapping against the wall. Upon closer inspection, she noticed that a draft from the baseboard was making the painting flap. The baseboard was removable, and as soon as it was taken off, it revealed a secret underground tunnel that led to a nearby bayou. The passage was used by Colonel Topp's slaves for escaping.

UNIVERSITY OF MEMPHIS

Originally established as the West Tennessee State Normal School, the institution currently known as the University of Memphis

opened on September 10, 1912, with Dr. Seymour A. Mynders as president. One dormitory on campus, the Mynders Residence Hall, is believed to be the home of a female spirit, thought to be the ghost Elizabeth Mynders. The female dormitory, one of the first buildings on campus, is believed to be named in honor of Elizabeth, daughter of the university's first president. Tradition states that the building was designed in the shape of the letter "E" to honor her memory.

Supposedly, Elizabeth died at an early age from some type of illness, although some rumors claim that she died in a mental institution. The ghost often appears to students who are not as studious as their peers. Students have reported coming back to their dorm rooms late at night from parties to find their textbooks open to the exact pages they should be studying. While most students consider Elizabeth to be a friendly spirit, some students have heard claims of the ghost wandering the halls telling students to "get out." She is most often seen in the hallways, and most reported sightings come from the third floor. Another location on campus believed to be haunted is the old campus library. John Willard Brister Hall served as the university's main library from 1928 to 1994. Apparently, a female student was raped and killed in a dark corner of the library. No one ever came to her rescue, and no one was ever charged with the crime. According to Laurie Snyder, College of Communications and Fine Arts associate dean for undergraduate programs, while no murder ever occurred at the library, there was a report of a rape.

Campus police have responded to screams of "help me" coming from the building but, after investigation, found no one inside. Students who spent late nights in the library reported hearing eerie, howling noises throughout the library building. Custodians have also reported seeing the ghost appear and disappear in front of them.

One elevator at the University Center on campus was thought to house the spirit of a construction worker who fell from the third floor while the center was being built. The elevator would occasionally reset itself to different floors. Also, when the elevator was carrying passengers, it would stop on each floor, credited to the

construction worker having some fun while enjoying the ride. The University Center was demolished in 2007 and a new center built in its place.

RHODES COLLEGE

Rhodes College, formerly known as Southwestern, has been at its present location in Memphis since 1925. The school is often noted for its beautiful campus and stone, Gothic architecture–styled buildings. Several buildings on campus are rumored to have a haunted history.

The fraternity house for the Theta Chapter of the Pi Kappa Alpha was one of the first buildings on campus, built in 1926. Reports of a ghost in the house can be traced as far back as the 1950s. Over time, the ghost has been given the nicknames "Ralph" or "Harry" or simply referred to as "the Ghost."

Fraternity members have heard footsteps ascending the wooden stairs to the second floor, but the footsteps never descend. Fraternity members who have slept upstairs have admitted that they only felt safe with the door locked. Typical in a haunting, fraternity members often have the feeling that they are being watched by something unseen.

In the kitchen, the water faucet will occasionally turn on by itself. The ghost is also known to disrupt the billiard table. Sounds of someone playing pool are often heard in the house. Upon inspection, the pool balls will be scattered across the table. Later, the crack of the cue and the sound of balls striking can be heard again. After a second inspection, the balls are racked neatly and the pool cues have been put away.

At least four stories have been passed down by previous fraternity members to explain the ghost. In one version, a young fraternity member hanged himself from the rafters of the chapter room because he had lost his true love. In the second story, the ghost is a construction worker who was supposedly killed while working in the house when a fieldstone fell on his head. In the third story, the ghost came to the house because it felt a connection

with the chapter room chandelier, which supposedly came from a bordello in Mississippi. The fourth story claims that the granite mantelpiece on the large stone fireplace in the chapter room was a damaged tombstone for a young man and that the family refused to accept it.

Other locations on campus—such as the third floor of the Bellingrath Dormitory, the sixth floor of the old Borrow Library and the McCoy Theatre—are also believed to be haunted. The dormitory, which houses second- and third-year female students, claims to have a ghost that roams the top floors of the residence hall. The ghost sightings usually happen at night. At the library, students have often felt that they were being crowded by something unseen and have also felt the presence of something rushing them down the stairs. The McCoy Theatre is also known to have paranormal activity. The sounds of a flute being played have been heard when the building is supposed to be empty.

SOUTHERN FOLKLORE

THE GUARDIAN DOG'S GHOST

The Guardian Dog's Ghost may be the oldest ghost story in Memphis, actually predating the founding of the city, going back to a time before European settlers. On a dark night in early winter, if you stand on just the right spot on the bluffs overlooking the Mississippi River, you can hear the eerie howl of an unearthly animal.

Fishermen reported hearing the sound, as well as people who once lived down at the bluffs. According to the legend they'd heard, the wail belongs to the spirit of the "sacred guardian dog" of the Chickasaw, who has returned and is demanding a sacrifice.

The story of the Guardian Dog's Ghost has its roots in an old Chickasaw legend. According to legend, the now separate tribes of the Chickasaw and Choctaw were once one in the same, living in the far west. After some time, a number of the tribe members decided to search for a new land to settle. Before they left, the group of approximately thirty thousand people was given two charms by a medicine man of the tribe in order to guide and protect the way. The first gift was a large white dog, whose duty was to warn his people against any danger that they might encounter on their journey. The second gift was a red pole, which they called a sanctified rod.

Each night of the journey, the tribe's chief would perform a ceremony and then plant the sanctified rod into the ground.

According to prophecy, the following morning, the pole would be leaning in the direction in which they were to travel. Night after night the pole was planted, and each morning when the tribe awoke for the day, the pole was pointing east. Eventually, the tribe came to the largest river they had ever seen, the river now known as the Mississippi.

They camped on the west bank of the river for several days, building rafts from driftwood and logs in order to cross. Tradition states that the tribe attempted the perilous river crossing during a storm. Several of the rafts were overturned and hundreds of members of the tribe drowned. But their greatest loss was not something of a material value, but something they held sacred, something that had kept up their morale, through the long tiresome journey—the sacred white dog had been caught in the treacherous waters of the Mississippi that day and drowned.

The grief-stricken travelers made their camp on the bluffs and conducted their usual ceremony that evening. In the morning, they woke to a great surprise. When the chief went to the pole, he found it standing straight, just as it was the night before. That night, the older men of the tribe held a meeting and decided that this action of the rod must be a sign for them to settle in the region of the bluffs. According to legend, not all of the elders of the tribe agreed that night about the symbolism of the pole, and a separation of the tribe took place. Chief Chickasaw decided that he and his followers would obey the action of the gods and settle somewhere in the region of the bluffs. Chief Choctaw held the adverse opinion and led his followers farther south. This is the story of how the once friendly tribes became separated.

THE GOLD HUNTER'S CULT

While Beale Street was always known for its music and nightclubs, most people never knew about the street's dark side. In the 1940s, Lieutenant George W. Lee began sharing his knowledge of Beale Street folklore. Although he changed the names of the people involved, Lee introduced Memphians to a world they could never

imagine. Lieutenant Lee served as a lieutenant in the United States Army during World War I. During the 1920s and 1930s, he became a leading Republican and businessman in the African American community.

One of Lee's stories involved a group of men referred to as "the Gold Hunter's Cult," who dabbled in a bit of voodoo and the spirit world. Lee claimed that there were four or five of these groups in Memphis, which were incredibly difficult to join, and it was even harder to get members to discuss what took place on their adventures. Groups of men (rarely, if ever, were women involved) escaped into the dark countryside to take part in strange ceremonies in which they covered themselves with devil oil to ward off evil spirits and prayed to the spirit world to point the way to a buried treasure of gold. The men involved in these groups claim that they often dug holes as big as houses, but just as they reached the treasure, spirits and shadowy apparitions appeared and ran them off.

Lieutenant Lee was introduced to the Gold Hunter's Cult by a secondhand clothier named Simkins. His introduction came soon after a court case involving voodoo and buried treasure became the talk of Beale Street. Two men, calling themselves Barefoot and Midnight, were codefendants on charges of obtaining money under false pretense. The state argued that the two men had obtained money from a local herb doctor, Dr. Scissors, in order to purchase certain ingredients to protect themselves from evil spirits while they dug for a hidden treasure buried under a house in the Wolf River Bottoms. Barefoot and Midnight claimed that on the night they dug for the gold, the spirits objected to the presence of Dr. Scissors. Items on exhibit in the courtroom included a divining rod, a dead frog, a bag of feathers from a black hen and a serpent's tail. The police called the whole story a clever con game. However, many of Beale Street's patrons remembered hearing about an undertaker in North Memphis, also a known treasure hunter, who suddenly seemed to come into a bit of money when all others in his field were struggling.

Lee's acquaintance, Simkins, was the owner of a Jacob's Rod, a prized possession for any treasure hunter, which was used to help locate buried gold. The members of one gold hunter's cult never

Beale Street.

could raise enough money to purchase a Jacob's Rod, nor would Simkins let anyone borrow it, not even for one night. So eventually, the members decided that Simkins should be initiated into the group, and because of his Jacob's Rod, he held a high amount of influence over the others.

One night, Simkins took Lee to see the head of the cult, known as "the Old Man." The Old Man was actually a fairly ordinary fellow, who even worked on the WPA. The Old Man greeted the two and took them back to the gold hunter's private meeting room, furnished with a dilapidated sofa and cane-bottom chairs. The room also included several tools used for digging and a lantern. Leaning in the corner were a divining rod and the Jacob's Rod. Three other members of the group were already present.

As the men sat down, the Old Man announced that it would be a good night to dig, because the sun set behind a cloud earlier that evening. As the men sat around the table, their leader explained the circumstances that brought the group there that night.

The Old Man had received a vision. A few nights previous, the ghost of Tom Buford came to him in a dream and told him exactly where he could find a pot of gold worth thousands of dollars that was buried by "Old Colonel Potterfield" at the start of the Civil War. According to the Old Man, Tom had been one of Colonel Potterfield's servants. For the previous four nights, the Old Man had also been in contact with the spirits. On the last night, he heard voices telling him to go to the Arkansas River Bottoms and follow the trail along the river until he reached a cabin, and there he would find a man. Then the Old Man was shown the image of an old mansion with a tall man standing in the yard pointing at the ground. In his vision, a flash came out of the man's pointing finger, causing the ground to peel away, exposing a big iron treasure chest.

The Old Man told the group that after his visions, he went to the river to explore and found Tom Buford's brother; he then asked him about Colonel Potterfield.

Tom's brother told the Old Man that Colonel Potterfield had three sons who were all killed during the Civil War. The colonel's wife had also died soon after the war ended. After the colonel passed away, his once grand home became abandoned, except for the ghosts of Potterfield family members and a few stray black cats.

Simkins was extremely hesitant about digging in the colonel's yard, but the Old Man said that he could get the undertaker from North Memphis to fund the trip if Simkins would let them use the Jacob's Rod. The men set off that night around 8:00 p.m. with the Jacob's Rod, the divining rod and several tools for digging. The men crossed the bridge over the Mississippi River and followed the roads and trails until the weeds grew so tall that they almost choked the car. At that point, the men left the car and set out on foot.

Clambering through the dense brush with only the moonlight as a guide, the men soon came to an opening in the trees. There in front of them stood the old Potterfield estate. The Old Man told them to stop for a moment, pulled out a bottle of devil oil and then applied the pungent liquid to his face and hands before passing the bottle to the other group members. The men then

cautiously approached the mansion's gate. Once they passed through, their leader asked them to form a circle around him and sit on the ground.

Suddenly, he dropped to his knees and began to rock, repeating a prayer that Lieutenant Lee had never heard before, calling out names such as Beelzebub and Melchior. He then stood up and asked the others to do the same. Then he had the group members step back ten paces and lay on the ground. He applied more devil oil to his body and brought out the Jacob's Rod. He pointed it toward the sky, which caused a light to shine on the ground. At that spot, he dug a small hole, poured in a liquid and dropped a lit match. Blue flames shot out of the hole as the liquid began to boil and steam. Then he took out an auger and began boring down into the hole. Quite some time had passed before the Old Man finally announced that he had hit something. It was now time for the men to dig. After an hour had passed, they had almost reached the spot where the auger hit.

Just at that moment, Simkins cried out "What's that?" The men looked up to see a white robed figure exit the old carriage house, a lit torch in hand. Then men took off running toward the car. After regaining their nerve, the men decided to head back to the hole and try to finish digging. Soon after they returned, they struck an iron plate. Just then a bloodcurdling scream broke through the night. The men ran back to the car, this time too afraid to return.

As they drove back to Memphis, nobody said a word. They never spoke of Colonel Potterfield's ghost or of treasure again.

ON SACRED GROUND

ELMWOOD CEMETERY

Elmwood Cemetery, located at 824 South Dudley, is the oldest active cemetery in Memphis. It was founded in 1852 by fifty wealthy Memphians, each subscribing $500 for one share in Elmwood Cemetery Association stock. The cemetery's name was chosen in a drawing when several proposed names were placed in a hat and "Elmwood" was drawn. Elmwood was established during a cultural movement in America that romanticized cemeteries and the concept of death. Cemeteries were now being viewed like public parks more than simply a crude burial ground. As Memphis was rapidly developing, it made sense to look outside the city limits for an appropriate setting for citizens' loved ones. Overcrowded cemeteries downtown were becoming hindrances to the population and in terms of business expansion. Eighty acres of rolling, wooded landscape were purchased two miles outside the Memphis city limits for the cemetery, and the streetcar line was extended to the cemetery gates to make it easily accessible to the public.

Since its creation, Elmwood has become the final resting place for both the famous and the infamous—and of course ordinary people as well. You can find the graves of war veterans, prominent political leaders, martyrs, madams, spies, outlaws and murderers. People who never would have associated with one another in life are now located next to one another in death.

Elmwood Cemetery is entered by crossing a bridge built in 1903. Located on just the other side is the cemetery office, a Victorian Carpenter Gothic structure, which was added to the National Register of Historic Places in 1978. Elmwood is designed like an English garden, with winding roads, large trees and rolling hills.

With over seventy thousand people now buried at Elmwood, it should come as no surprise that the cemetery has its share of ghost stories. In 1982, caretaker Murry Hargrove had his first experience with ghosts while closing the cemetery just around dusk. While crossing the grounds, he noticed four men gathered at the tallest hill in the center of the cemetery, known as Lenow Circle. He also noticed that these men were cloaked entirely in white with top hats and tails. As he approached, the men didn't walk away—they simply glided away. His entire encounter lasted no longer than a minute, and the four men never seemed to notice the caretaker.

The four men are believed to be David Park "Pappy" Hadden, Napoleon Hill, Henry A. Montgomery and Archibald Wright, each notable in his own right. These four men were known throughout Memphis for meeting at the corner of Madison Avenue and Main Street every morning to discuss business, politics and to simply enjoy one another's company—a tradition the four seemed to have carried over into the afterlife.

The four men were such a well-known group that an artist captured their images in an oil painting. The painting, created around 1880 by C.P. Stewart, hangs in the second-floor hallway of the Woodruff-Fontaine House. It was given to the Memphis Chapter of Association for the Preservation of Tennessee Antiquities (APTA) by Geraldine Montgomery Jones, granddaughter of Henry Montgomery. The painting depicts the four men in conversation at the northwest corner of Main and Madison. The ticket office of the Louisville and Nashville Railroad and the original federal post office can be seen in the background.

David Park Hadden served as the third president of the Taxing District, from 1882 to 1890, during the decades in which Memphis lost the city charter. Hadden also invented the "Hadden's Horn," a cup used to shake the dice in gambling games (to ensure that no one could cheat).

On Sacred Ground

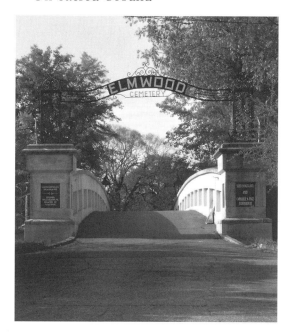

Historic Elmwood Cemetery is the oldest active cemetery in Memphis. *Photo by Laura Cunningham.*

Napoleon Hill was a well-established businessman whose interests included cotton, grocery, real estate and banking. He was also a founder of Union Planters National Bank.

Henry Montgomery was the founder and owner of seven of the earliest cotton compresses in Memphis. He also founded the Montgomery Race Track, a trotting track at the current location of the Mid-South Fairgrounds. Montgomery has one of the more unusual monuments at Elmwood. In life, Montgomery suffered from a terrible fear of public speaking. One evening, as he stood to give a speech, he dropped dead. At the time, it was said he died of stage fright, whereas in modern times the cause of death would most likely be attributed to a heart attack. The monument at his grave depicts Montgomery in his final pose, standing with his hand extended, as if giving a public talk. A small bale of cotton is depicted at his side.

Archibald Wright was a leading Memphis attorney who was also appointed to the Tennessee Supreme Court.

Another legend involving the four men claims that they meet at the top of the Lenow Circle hill every night at midnight. In fact,

their graves can all be viewed as four points of a square, with Lenow Circle directly in the center.

The cemetery's main office, referred to as "the Cottage," is also known to have its own ghost, who turns the water faucet located in the back of the building on and off. In 1866, a small cottage was built for the cemetery's superintendent, Samuel Phillips, who was on call twenty-four hours a day. In 1897, the Cottage became Elmwood's business office. A walk-in vault for cemetery records and a small parlor were added to the building in 1903.

The ghost of murderess Alice Mitchell also haunts Elmwood. Photographs taken at her grave site often show her headstone blurred and surrounded by orbs. In January 1892, Alice Mitchell went down to the steamboat landing at the river to say goodbye to her friend Frederica "Freda" Ward. Unbeknownst to anyone, Alice brought her father's shaving razor with her and slit Freda's throat on the cobblestones. At the murder trial, evidence was introduced that nineteen-year-old Alice and seventeen-year-old Freda had an "unnatural relationship," and when Freda's sister insisted that the girls stop seeing each other, Alice became distraught. In interviews with her lawyers, Alice claimed: "I resolved to kill Freda because I loved her so much that I wanted her to die loving me, and when she did die I know she loved me better than any other human being on earth." The jury deliberated twenty minutes before finding Alice "presently insane." She was committed to the state mental hospital in Bolivar. Alice died at the hospital in 1898. Her death was reported as tuberculosis, but some say that she killed herself by jumping into the water tower on the hospital's roof. Alice was buried at Elmwood, in direct view of Freda's grave.

OLD RALEIGH CEMETERY

The Raleigh Cemetery is the final resting place for many of Shelby County's earliest residents, believed to have been used as early as 1831. Isaac Rawlings, second mayor of Memphis, was buried at the cemetery in 1839 and is among the more prominent citizens buried there. In the earliest days of settlement, the town of

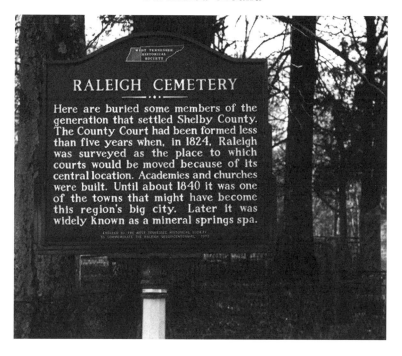

The Raleigh Cemetery is one of the oldest cemeteries in Memphis. The first burial took place in 1841.

Raleigh, established at Sanderlin's Bluff over the Wolf River, was a prosperous rival to Memphis. From 1827 to 1867, Raleigh served as the county seat of Shelby County. In 1866, the courts moved back to Memphis, and the town of Raleigh began to decline. In the late 1800s, Raleigh saw an increase in popularity due to the mineral springs in the area, noted for their purity and medicinal qualities. As Memphis expanded, Raleigh was eventually incorporated into the city.

The seven-acre cemetery, located on Old Raleigh-Lagrange Road and East Street, is filled with spirits showing themselves in photographs as orbs or wispy sheets of mist. Floating apparitions have also been seen there. The cemetery was originally maintained by Raleigh Cumberland Church; once the church left, the City of Memphis helped maintain it. In 1986, the property was deeded to

the Raleigh Heritage foundation. The cemetery is in desperate need of maintenance. Ongoing efforts are being made to preserve the cemetery, but in recent years it has proven increasingly difficult.

SHELBY COUNTY CEMETERY

The Shelby County Cemetery, currently located at 8340 Ellis Road, serves as the free cemetery for its residents. Originally, the free cemetery was located on sixty acres on Hindman Ferry Road and North Watkins. Burials began taking place there soon after the county acquired the property on November 7, 1891, although records have only been kept since 1911. In its earliest days, the cemetery was often referred to as Potter's Field, though that was never its official name. In April 1934, the cemetery was officially named Shelby County Cemetery. The cemetery was moved to its current location in 1965. In 1965, the Ed Rice Community Center and Frayser Park were built on top of the old cemetery. While some graves were moved to the new location, most were not.

With tens of thousands of nameless graves, it comes as no surprise that the cemetery is supposedly haunted. According to Michael Einspanjer, founder of Memphis Paranormal Investigations, the cemetery's most distinctive ghost is Arthur. The group nicknamed him "the Cucumber Man" because when he is nearby he gives off the fragrance of fresh-cut cucumbers. Arthur is especially fond of females.

EGYPT BAPTIST CHURCH AND CEMETERY

The Egypt Baptist Church and its adjacent cemetery, located at 4454 Raleigh-Millington Road, are both well known for paranormal activity. The church is one of the oldest Baptist Churches in Shelby County. Church members have heard the sounds of a piano being played, drifting throughout the building when it was known to be empty. Footsteps can also be heard wandering the halls.

On Sacred Ground

Next to the church is a cemetery whose residents are not always happy to have company. Visitors have reportedly felt like they were being watched and also had an uneasy feeling, like someone was rushing them to leave. On one occasion, a person returning from viewing a grave site found his vehicle's tires flat.

THE GHOST AT THE CORNER

At the corner of Chelsea Avenue and Sixth Street stands a Memphis landmark known simply as "the Old Brick Church." When the church was founded by fourteen charter members in an area of Shelby County called Seclusival, the church's formal name was Third Presbyterian Church. Established in 1856, the church took four years to complete at a cost of $11,250. The land and a large portion of the money came from Colonel E.H. Porter, whose son, Reverend Edward E. Porter, became the pastor. Reverend Porter served as the pastor for the church until April 27, 1862, when he resigned to become a chaplain in the Confederate army.

Once Memphis fell to the Union during the Civil War, General Grant and his men took control of the church. The lower floor of the church was used for storage and as a stable for horses and army mules. The upper floor served as a hospital for Union soldiers. During the war years, church members held services in a cabin at 968 Seventh Street. Forty years later, the government reimbursed the church $1,200 for usage during the war. In 1916, the church was renamed Chelsea Avenue Presbyterian Church.

Ghost sightings tend to be unreliable; usually, no one can predict when a ghost will appear. However, in August 1889, this was not the case. That summer, a young woman began appearing at the corner of Chelsea and Sixth Street every night at exactly 2:30 a.m.

Even back in 1889, there were sections of Memphis where a woman standing on a street corner late into the night would go unnoticed, but not so in this neighborhood. Night after night the woman appeared; neighbors speculated and gossiped but were content to simply let her be without confrontation. The mysterious woman looked to be twenty years old, tall and thin with flowing red

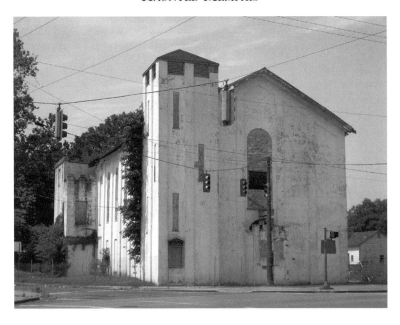

Chelsea Avenue Presbyterian Church, known since its inception as "the Old Brick Church," served as a stable and hospital for Union soldiers during the Civil War. *Photo by Laura Cunningham.*

hair. She wore a long white robe tied at the waist with a black sash. She wore a dark, broad hat that covered her eyes.

It did not take long before people began to joke about the woman on the corner. Young men chided their friends as they passed her in the street: "There's your girl, waiting for you," or "Here comes my sweetheart." Soon the neighborhood just accepted her as yet another crazy woman, and they let her be.

After the woman had long become a familiar fixture in the neighborhood, a group of young men decided to take it upon themselves to find out who she was and why she stood on the corner every night. One evening, they approached her, but as soon as they got within a few feet of her, she turned and walked to the side door of the church and vanished. The bewildered men checked the door and found it locked, so they moved on for the night. The men returned the next two nights with the same outcome—the

woman would head to the door fronting Sixth Street and simply disappear. The group decided they would hatch a plan to capture the vanishing woman.

Night after night, as word of the mysterious woman spread, groups as large as a dozen men showed up attempting to capture the woman, who Memphians now believed to be a ghost. But try as they might, she was simply too fast for them. On one occasion, the police were brought in, and they, too, could not catch the ghost. She always went directly to the door and disappeared.

Finally, one young man had the idea of cutting the ghost off at the door instead of chasing her from the street. One night, he arrived at the church at exactly 2:28 a.m. and stood in position blocking the side door of the church door. He knew if the ghost made her appearance and kept her usual routine, which she had now been doing for weeks, she would be forced to come in contact with him. While he waited, he nervously glanced up and down the streets. There was no sign of anyone except an old dog, sleeping peacefully on a front porch. He gripped his pocket watch tightly in his hand, watching with anticipation as the minute hand finally clicked 2:30 a.m. At that moment, he looked up and there, standing at the corner, glowing in the moonlight, was the young woman. He waited for her to move, but she seemed content to stare mournfully into the darkness. Finally, the young man coughed loudly to get the ghost's attention and called to her to come to him. The woman immediately turned and quickly walked toward the young man. When she was within feet of him, she lifted her head, and he became the first person to fully look upon her. In an August 6, 1887 article with the *Memphis Appeal*, the young man reported: "And such a look! I have seen despair and horror depicted upon blanched features before, but the very worst was a sweet smile in comparison to this. Her large, sunken, yet lustrous eyes pierced me to the heart, and her mouth and cheeks put on a look of intensified terror that chilled me."

The ghostly woman reached out her arms, intent on embracing the man. He willingly embraced her back, only to realize that he was not actually touching her, for she had passed right through him. He turned around to find that she had gone straight to the door and

had turned back once more to the man, "fixing upon me a look that seemed intensified tenfold, and which no power on earth can secure my consent to look upon again." And then, she was gone.

ST. ANNE CATHOLIC CHURCH

St. Anne Catholic Church was originally established in 1910 as a mission, cared for by the clergy of St. Joseph's Church, and located at a house on Buntyn. In 1917, a church was built at the intersection of Carnes and Pine, now Goodwyn, and named St. Sebastian. The first church service was held on June 10, 1917.

In 1937, Father Thomas F. Nenon was named pastor. The parish had outgrown its previous facilities and began construction on recently purchased property at the corner of South Highland and Kearney. Two houses on the property were converted for church use. The parish converted one house to a three-room schoolhouse. The second house served as the rectory. The Sisters of Charity started a school at the church. At this time, the Sisters lived at St. Peter Orphanage and were transported to the school each day. The church was officially dedicated on September 5, 1937, and named St. Anne Catholic Church.

In May 1948, under the direction of Father Nenon, the parish began construction of a new combination church and school. The church would be located on the lowest level, with the school occupying the middle floor and half of the top floor. The Sisters of Charity occupied the remaining half of the top floor until 1953, when a convent building was constructed for them. Father Nenon was passionate about the construction of the new church and school. Concerned church members told him several times to rest, slow down and take time off.

Father Nenon died on June 18, 1959; however, he left his Memphis church three years earlier due to his ailing health. Many longtime church members will admit that they believe his spirit never left. Doors opening and closing, the sounds of footsteps and other odd occurrences throughout the building are attributed to the ghost of Father Nenon.

HOME SWEET HOME

WOODRUFF—FONTAINE HOUSE

The Woodruff-Fontaine House, located at 680 Adams Avenue, was built in 1870 for a carriage maker from New Jersey, Amos Woodruff. Woodruff hired architects Mathias Harvey Baldwin and Edward Culliat Jones to design his ornate, French Second Empire mansion. For nearly ten years, beginning in 1869, nearly all of the finest homes and grandest buildings were designed by Jones and Baldwin.

The mansion was built with handmade bricks. The home's hardwood floors are Southern cypress, with the first floor interlaced with bands of mahogany. The home's floor plan follows a traditional pattern of a long center hallway with rooms on each side. The ceilings in the home are sixteen feet high on the first level, fourteen feet on the second and thirteen feet on the third. The ceiling of the three-story central staircase is made of tin and decorated with garlands and cherubs. Outside, the home is styled with a steep mansard roof and a central tower that extends two additional levels above the three-story home.

A carriage maker by trade, Amos Woodruff expanded his business interests once in Memphis. He would eventually become president of two banks and hold interests in hotel, railroad, cotton, insurance and lumber companies. He lived in his home on Adams until 1884 with his wife Phoebe and their four children.

Amos's nineteen-year-old daughter, Mollie, became the first bride at the house, marrying Egbert Wooldridge on December 18, 1871.

The new couple made the mansion their home, living in a suite of rooms on the second floor. Unfortunately, the young couple would only have a few short years of happiness together. On February 13, 1875, Mollie gave birth in the home to a stillborn daughter. Three months later, Mollie's husband Egbert contracted pneumonia after a boating accident and died just three days later in the same room as his daughter.

The widowed Mollie continued to live with her parents until she married James Hennings on June 14, 1883. On January 13, 1885, Mollie gave birth for a second time; tragically, this child was stillborn as well. Mollie never had any children. In 1917, Mollie died of heart disease at her sister's home on Poplar Avenue. She was just fifty-six years old.

In 1883, Noland Fontaine purchased the home from the Woodruffs. The Fontaine family lived in the home for the next forty-six years. Fontaine was a prominent Memphian and third-

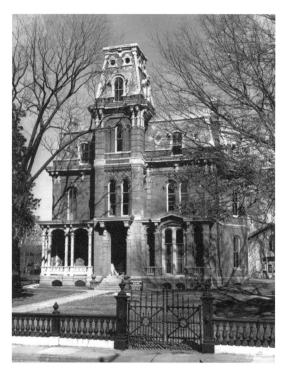

The Woodruff-Fontaine House, 1960. The home, once set to be demolished, was preserved by the efforts of the Memphis Chapter of the Association for the Preservation of Tennessee Antiquities.

wealthiest cotton factor in the country. Raising eight children ensured that the Fontaine's home was the scene of many elaborate parties with prominent guests arriving from all around the country. In 1892, on the occasion of the opening of the first Mississippi River bridge between St. Louis and New Orleans, the Fontaines entertained over two thousand people, including the governors of five states. Later in 1892, Grover Cleveland visited the home during the presidential election campaign. John Philip Sousa and former vice president Adlai Stevenson were once also guests at the home. Noland Fontaine died of kidney failure at the home in 1913 at age seventy-two. His wife Virginia also died at the home at age eighty-two.

Rosa Lee purchased the house for the James Lee Art Academy, named in honor of her father. In 1959, the Memphis Academy of Arts, successor to the James Lee Art Academy, moved to its present location in Overton Park. The buildings, willed to the city, stood vacant and vandalized and were scheduled for demolition. At that time, the Memphis Chapter of the APTA stepped in and saved the properties for preservation. The Memphis chapter, founded in 1953, raised $50,000 from a public fund drive and received permission for the restoration from Mayor Henry Loeb. The restoration efforts for the house, directed by Luke Eldridge Wright, began in 1961. The house opened as a museum in September 1964. When the museum first opened, it was unfurnished. Eventually, the museum was furnished and accessorized with period pieces, none of which belonged to the Woodruff or Fontaine families.

Although Mollie may have died in 1917, many believe she is still at home at her former house on Adams. Mrs. Elizabeth Dow Edwards, great-granddaughter of Mollie's sister, Sarah, was one of those believers. The only personal experience Mrs. Edwards has had with Mollie involved a slamming door. However, her friends have heard footsteps following down the stairs and a voice calling out "My dear." On one occasion, while Mrs. Edwards was conducting a tour, a woman walked into Mollie's old bedroom and grew quite pale and started to tremble. She told Mrs. Edwards that she was a psychic medium who could give messages from the dead. She informed Mrs. Edwards that Mollie's room was arranged

incorrectly and that the bed was near the wrong wall. The large half-tester bed stands against the south wall, but the medium felt it belonged on the east wall, closest to the central staircase.

When the mansion housed Miss Rosa Lee's Art Academy, students who lived and studied in the home often sensed Mollie's presence, hearing sighs and whispers originating from Mollie's old bedroom. Workers in the home during the restoration period reported feeling Mollie's presence—an unseen person walking behind them on the stairs.

The second-floor bedroom, known as the "Rose room," is the center of Mollie's activity, although she occasionally wanders throughout the rest of the house. This is the room, now currently decorated with pale cabbage rose wallpaper, in which Mollie's baby daughter and husband both died. The room often becomes extremely cold with no apparent cause. Occasionally, the room will fill with a musty odor. One tourist walked into Mollie's bedroom and immediately began having a hard time breathing. She turned to her guide and asked, "Who died in this room?"

While visitors to the home have experienced paranormal activity year round, there is a noticeable, heightened sense of disturbance from February to May every year, corresponding to the time between the deaths of Mollie's daughter and husband.

Visitors to the home have claimed to hear a baby crying and a woman's voice lightly whispering. On the day before the anniversary of Egbert's death, employees heard the sounds of a woman's muffled crying. When they climbed the stairs to investigate the source of the noise, the crying stopped by the time they reached the first landing. They walked around Mollie's room, but everything was normal. After they got downstairs, the crying started up again.

The bed in Mollie's room has also been disturbed by an unseen entity. Several witnesses saw wrinkled bedsheets smoothen out before their eyes, as if someone had run her hand down the bed. People have also seen a human impression on the bed, as if someone was sitting on it. People have also witnessed shutters flapping violently, chandeliers swinging and doors slamming when no one was nearby. Mollie is also blamed for turning on lights in the house overnight.

While most of the interactions with Mollie's ghost are felt or heard, she has actually appeared to a few people. A woman, described as wearing an old-fashioned green dress, has been seen pacing back and forth in Mollie's room. Once, a seven-year-old boy on a field trip turned to his teacher and the tour guide and asked, "What happened to the lady who was just sitting in that chair?"

At least three psychics who visited the house reported the presence of a woman in the Rose bedroom. Each described Mollie in complete detail and was also able to point her out in old photographs. On one occasion, a psychic provided such a detailed account that an archivist recognized that the ghost from the description was wearing Mollie's "going away" dress from one of her weddings.

While Mollie Woodruff is known as the ghost at the Woodruff-Fontaine House, the home has a second ghost, who makes his presence known on the third floor. On this floor, visitors and employees have reported smelling cigar smoke. Although he has never been seen, people have sensed his presence and can clearly tell that the ghost is male. Along with simply not wanting visitors on his floor, he has shown violent tendencies and given many people quite a fright at the house. The ghost is decidedly more hostile toward women than men. Female visitors and employees have felt threatened on the third floor. One former director of the museum was pushed down the stairs. One woman reported being pushed along by something on the third floor and also being shoved into one of the bedrooms. However, when a male visitor came to the house, he sensed a ghost who seemed pleased to have him there and eager for him to stay. The ghost made him feel incredibly comfortable and at ease. Many believe that the third-floor ghost is Elliot Fontaine, who died in the influenza outbreak in 1918 at age thirty-four. Elliot was rumored to be a gay socialite and a bit snooty.

MOLLIE FONTAINE—TAYLOR HOUSE

Across the street from the Woodruff-Fontaine House sits the Mollie Fontaine-Taylor House. Located at 679 Adams Avenue,

Noland Fontaine had this Queen Anne Victorian mansion built as a wedding present for his daughter in 1886. During the years the home was under construction, Mollie and her husband, Dr. William W. Taylor, lived in her father's home across the street. After Dr. Taylor died in 1925, Mollie Taylor remained in the home until her death in 1939. The property changed hands numerous times, even being divided into apartments.

In 1965, the Memphis Housing Authority purchased the home as part of an urban renewal project. The home was selected as part of the project because it had restorative value and fit in well with the surrounding buildings on Adams Avenue, which were in various stages of being restored. Although the Mollie Fontaine-Taylor House is not as large as the other mansions on the street, it makes up for its smaller size with elaborate gingerbread ornamentation. The home is considered the best representative of 1880s architecture in the city of Memphis.

In the 1970s, the homeowner was a notorious ladies' man. He turned the home into a big party house. The home is also rumored to be the location for the first photo spread in *Penthouse* magazine.

In 1985, Karen and Bob Carrier purchased the home. The house was used as a home for the family and a location for Karen's catering business, Another Roadside Attraction. A few years later, she renovated the home's old carriage house and moved her catering business there. Already the owner of three other Memphis restaurants—Automatic Slim's, the Beauty Shop and D O Sushi—Karen converted the main house into the Cielo restaurant in 1996. In 2007, Cielo was modernized into the Molly Fontaine Lounge, named in honor of the home's previous occupant.

The ghost of Mollie is still rumored to be lingering around her former home. She's been blamed for items going missing and an occasional cake flipping over. On one hot summer night, the power went out at Cielo. The manager lifted his glass and exclaimed "Cheers to Mollie!" and the lights immediately came back on. People have been proclaiming "Cheers" to Mollie's ghost ever since.

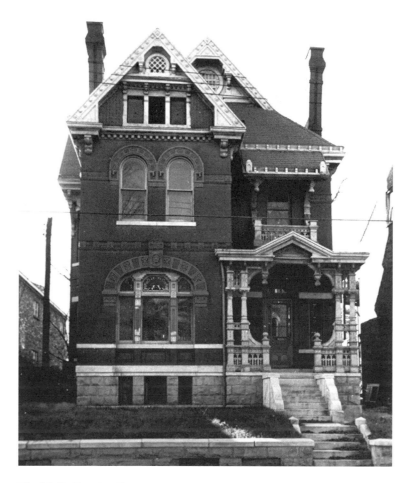

The Mollie Fontaine-Taylor House, 1962. Noland Fontaine built this house, located across the street from his own, as a wedding present for his daughter.

JAMES LEE HOUSE

Located next door to the Woodruff-Fontaine House, at 690 Adams Avenue, the James Lee House stands empty, waiting to be restored to its former glory. Looking through the window, you may still see

an art easel or paintbrush strewn about, left over from its days as an art school.

In 1848, lumberman William Harsson built a small, two-story brick home in the middle of farmland, which would later become the intersection of Orleans Street and Adams Avenue. In 1849, Harsson's daughter, Laura, married Charles W. Goyer, who had arrived in Memphis in 1841 by flatboat when he was just seventeen years old. By 1852, Goyer had prospered in his career as a merchant, and he saved enough money to purchase the home from his father-in-law. In 1865, a second addition to the south side of the home was added. By 1871, he expanded his home to its present day front and three-story tower. One story alleges that Goyer, a sugar and molasses importer, grew so rich that he formed the Union Planters Bank in order to have a place to keep his money. In the late 1860s, Laura Goyer died in the home from yellow fever. After her death, Charles Goyer married Laura's sister, Charlotte.

In 1890, Captain James Lee, son of the founder of the Lee Line steamboat company, purchased the home from the Goyer family, moving from his previous home down the street at 239 Adams. James Lee, a Princeton graduate, moved to Memphis in 1860 to practice law. In 1877, he retired from his law practice to join his father's company, the Lee Line of river packets and steamers based in Memphis. Lee's daughter, Rosa, was the last family member to live in the home.

In 1961, the Memphis Chapter of the APTA saved the buildings from demolition by leasing them from the City of Memphis for restoration and public viewing. While the James Lee House has benefited from repairs over the years, any efforts thus far to restore the James Lee House for public viewing have failed.

For decades, the ghost of a woman wearing a red dress has been seen throughout the old house. Psychics and parapsychologists who have visited the mansion have felt the presence of an agitated female spirit. Workers making small renovations to the house have also sensed movement in different rooms. Students who attended the art academy often saw a woman wearing a flowing red dress seemingly glide down the front staircase and

Home Sweet Home

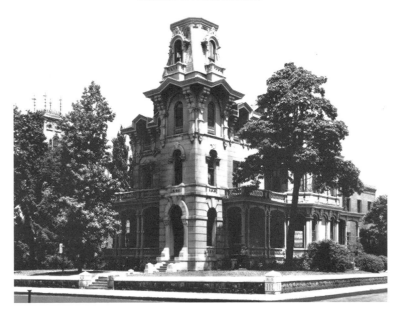

In 1925, Rosa Lee established the James Lee Memorial Academy of Art in her former home, named in honor of her father.

vanish before their eyes. The woman is thought to be Laura Goyer, the daughter of the first homeowner.

Some say that she returned after death to check on the welfare of her children. Others allege that Laura returned furious and unable to rest because she felt betrayed by her husband and sister. The oldest section of the home contains an apartment, whose tenants serve as caretakers for the house. A former caretaker once reported a rocking chair that rocked by itself and a woman in a red dress standing in the corner of the apartment. Many people claim that they can feel an intense, angry energy emitting from the house. The anger is so strong that it can be felt by those in cars driving by on the street.

THE MALLORY—NEELY HOUSE

The Mallory-Neely House Museum, located at 652 Adams Avenue, was once considered the most accurate example of upper-class life in late nineteenth-century Memphis, possibly in the entire country. The museum's authenticity is directly linked to the preservation efforts of "Miss Daisy" Mallory. Born Frances Daisy Neely, Miss Daisy moved into the house in 1883 when she was twelve years old. She continued living in the home until she died in 1969, at age ninety-eight.

In 1852, Isaac B. Kirtland, a banker from New York, began construction on a large, two-and-a-half-story home on Adams Avenue, designed to resemble an Italian villa. He purchased the three-acre lot for $5,500. In 1864, Kirtland sold the home and one acre of land to Benjamin Babb for $40,000. Babb came to Memphis in 1844 and began working in the cotton industry. By 1881, he had become so successful that he and his brother-in-law established their own firm, Benjamin Babb & Company.

In 1883, James Columbus Neely purchased the residence with his wife, Frances, and their five children for $45,000. J.C. Neely had moved to Memphis in 1854 and became a cotton broker and wholesale grocer. The Neely family made extensive renovations to the house throughout the next decade. They expanded the house to three full floors with a four-story tower. The final result was a sixteen-thousand-square-foot, twenty-five-room mansion with a fireplace located in almost every room.

The family decorated the house in an elaborate, high Victorian style. Parquet flooring, ornamental plasterwork and elaborate stenciling on the ceilings were all added to the home at this time and still remain in the home today. Mr. Neely purchased two ornate stained-glass windows at the 1892 Columbian Exposition in Chicago. One window was installed in the home's front doors. The second window was showcased at the back of the central hallway. A new staircase was designed for the house, with a landing designed specifically for the window. Several other large furniture pieces were purchased at the Chinese exhibit at the 1903 World's Fair in St. Louis.

Home Sweet Home

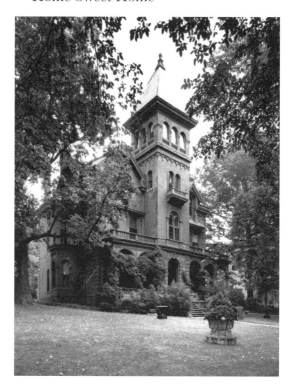

The Mallory-Neely House is considered one of the best-preserved Victorian homes in the country.

In 1900, the Neelys' youngest daughter, Daisy, married cotton factor Barton Lee Mallory, who along with his father founded W.B. Mallory & Sons mercantile firm. The couple established themselves in the home, which is also where they raised their three children, William Neely and twins Barton Lee and Frances. The Neelys' daughter Pearl also lived in the home with her husband Daniel Grant and their children.

Barton Mallory died in 1938, but Daisy remained in the residence. She made very few changes to the house, keeping the home's turn-of-the-century style and furnishings. Before she died, Miss Daisy made her desire known that she wanted the house preserved as a historic museum. In 1972, her heirs donated the house and furnishings to the West Tennessee Chapters of the Daughters, Sons and Children of the American Revolution. The group began operating the home as a house museum. The group

gave the deed to the home to the City of Memphis in 1985, and in 1987, the Memphis Park Commission began overseeing the house museum in addition to the Magevney House Museum.

Over the years, a variety of individuals and groups have contributed to the preservation of the home and its furnishings. One of the most recent long-term restoration projects began in 1995, when a twenty-square-foot section of ceiling in the double parlor collapsed. Preservation experts from Washington, D.C., were called in to help with the restoration process, which continued after they left. The second-floor flooring was removed in order to stabilize the parlor's ceiling, which exposed electrical wiring from 1893 and plumbing from the 1920s. Due to a lack of funding, the flooring was not replaced, and several other projects were left incomplete.

When the home first opened as a museum, a suite of rooms on the second floor was converted into an apartment, used by a member of the DAR. The first occupant of the apartment admitted that she had experienced some odd occurrences but nothing that she would consider spooky. In fact, she actually had the feeling that Miss Daisy wanted her there. That first tenant was not the only one who felt like that. Over the years, many former employees remarked that they always felt warm, welcoming vibes in the home, a sharp contrast to the next-door Woodruff-Fontaine and James Lee Houses.

Some odd occurrences have taken place at the house, which may or may not be the work of spirits. Once, a self-proclaimed ghost hunter toured the home, capturing dozens of photographs. In the downstairs parlor, she made several comments regarding how lovely and inviting the home was. As she snapped the next photograph, the camera's flash illuminated hundreds of sparkles throughout the room, and the hairs on the arms of everyone in the room stood on end. The feeling of energy lasted for several minutes.

An indigo-colored orb of light once appeared on the ceiling in the second-floor hallway. The orb appeared in a location not reached by sunlight, and no source for the light could be identified. The orb was pointed out by a visitor to the museum on the first tour of the day, and after the first initial sighting, it was never seen again. The tour guide had been running late that morning and had failed to open

the museum on time. She had spent the entire tour fearful of getting in trouble, but her fears dissolved after seeing the light. After sharing her story, she and several others believed that it may have been a sign from Miss Daisy, assuring her that everything was all right.

Other visitors to the home have claimed to see the image of a woman sitting at the window of the third-floor bathroom, crying to herself. Many people have also had an eerie feeling in one of the bedrooms on the third floor. After the house became a museum, the room was used for storage and only rarely did someone venture inside. A mother and daughter cleaning crew once reported seeing an older woman, with untamed white hair, peering down the stairwell from the third floor. After that sighting, the daughter refused to be in the main house alone.

Allegedly, the Mallory family had their own ghost story. One Halloween night, guests were arriving at the house for a party. Through the open front door, one person spotted a disembodied hand creeping down the banister of the grand, central staircase.

In 2005, the Mallory-Neely House Museum fell victim to a lack of funding and was officially closed until further notice. Despite efforts to reopen the house, the museum remains closed to the public at this time.

THE HUNT—PHELAN MANSION

Located at 533 Beale Street, the Hunt-Phelan House is one of the most historic homes in Memphis. Five presidents are believed to have slept here. General Grant made the home his headquarters during the early part of the Civil War, and Federal generals are said to have planned the Battle of Vicksburg in the home's parlor. For a brief time, the home was also used as a hospital and to house teachers sent by the Freedmen's Bureau to educate freed blacks. Andrew Jackson eventually turned the home back over to William Hunt, its rightful owner. The home is the only one of its stature remaining in the area.

The original owner of the home was George H. Wyatt, who began construction on his house two miles from the center of

Memphis in what was then a heavily forested area. The original ten-acre property included a smokehouse, stables and slave cabins. The house was completed in 1832. The following year, Wyatt's cousin, Colonel Eli M. Driver, moved into the home. He eventually purchased the property from another cousin in 1850. Colonel Driver's daughter, Sarah, married Colonel William R. Hunt, who took possession of the home in 1851. Six generations of the Hunt family and their descendants, the Phelans, would live in the home. In 1993, Stephen R. Phelan, the last member of the family to live in the house, passed away. For a brief period of time in the 1990s, the home became a house museum, preserving the house's unique history. Currently, the home is being used as a bed-and-breakfast called the Inn at Hunt-Phelan.

Allegedly, seventeen soldiers died in the house during its time as a Civil War hospital, among them Private William McClintock.

The Hunt-Phelan Home, currently operating as a bed-and-breakfast, is considered one of the most historic homes in Memphis. *Photo by Laura Cunningham.*

Home Sweet Home

McClintock was shot in the leg, which then had to be amputated. While he was being treated, he accidentally let it slip that he was actually a spy. He was hanged in the backyard. A sound seemingly of one leg hopping can be heard on the top floor of the mansion, which served as the hospital.

One popular legend claims that before the Hunt family fled Memphis during the yellow fever epidemic in 1873, the family gave their trusted servant Nathan Wilson a chest of gold to pay for the estate's finances. Not long after, Wilson himself became a victim of fever. When Wilson died, a pair of muddy boots and a shovel were found next to his bed. The story claims that Wilson buried the treasure before he died, telling no one where it was located. Supposedly, at midnight during a full moon, if you stand in the middle of three trees once located in the front yard, Nathan Wilson's ghost will appear and guide you directly to the treasure.

MAGEVNEY HOUSE

Of the historic buildings remaining in Memphis, the Magevney House, located at 198 Adams Avenue, provides the best idea of what daily life would have been like for Memphians in the decades following the city's founding. Built in 1833, the small, white, clapboard cottage originally consisted of just one room and a hallway. About 1837, a front parlor and upper floor were added to the home. In the mid-1850s, two rooms were added to the back of the home, giving it an "L" shape.

The house was bought in 1837 by Eugene Magevney. Magevney is believed to have been a boarder in the house before purchasing it for himself. Mr. Magevney was born in County Fermanagh, Ireland, in 1798. He studied for priesthood but changed his mind and became a teacher. In 1828, he came to Pennsylvania, where he spent five years before arriving in Memphis at the age of thirty-five. He became the city's first permanent schoolteacher. He taught young men in a small log cabin located in Court Square. Tuition was often paid in land.

Mr. Magevney soon became a prominent member of the Catholic community. In 1839, the first Catholic Mass in Memphis

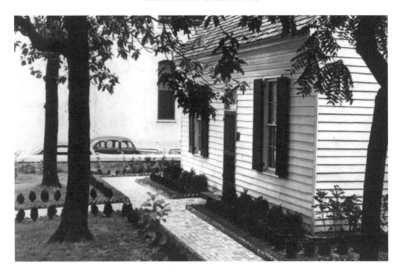

The Magevney House was the home of Eugene Magevney, the first permanent schoolteacher in Memphis.

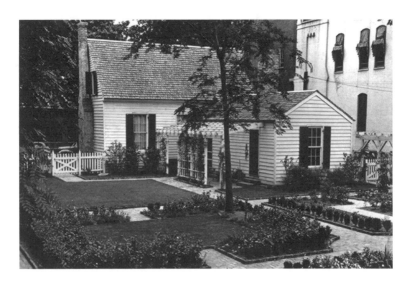

During an excavation of the backyard at the Magevney House, bottles and other artifacts were discovered and put on permanent display in the house.

was held in the parlor of his home. In 1840, Mr. Magevney sent for Mary Smythe, one of his former students from Ireland. Their wedding was the first Catholic wedding in the city. The couple had two children, Mary and Kate. The city's first Catholic christening took place in the Magevneys' parlor, soon after Mary's birth.

In 1840, Mr. Magevney retired from teaching to focus on his real estate holdings. As the city grew, he amassed a considerable fortune from the land he had received as tuition payments. Despite his wealth, he continued to live in his modest home. Between 1842 and 1848, Mr. Magevney dabbled in local politics. He held the office of alderman and also ran unsuccessfully for mayor.

Eugene Magevney died in the 1873 yellow fever epidemic. His wife Mary died in 1889. The couple's oldest daughter Mary became a Dominican sister and established the Sacred Heart Convent in Galveston, Texas, in 1882. She died of cancer in 1891. The youngest daughter Kate, born in 1842, lived in the house until 1925. She married her first husband, John Dawson, in 1867. He later died in the home of congestion in 1872. She married her second husband, Hugh Hamilton, in 1882. The couple lived in the house with Kate's mother until his death in 1887.

After her father's death, Kate took over his real estate business. At the time of her death in 1930, the estate was valued at $3.5 million. Kate died without leaving a will, which resulted in a lawsuit that lasted eight years. The majority of the estate went to Blanche Karsch, Kate's adopted daughter, who gave the house to the city in 1941.

Under the direction of the Memphis Park Commission, the home was turned into a house museum, replicating a middle-class home in Memphis during the mid-1850s. The house had several outbuildings, which were taken down in preparation of the museum, including a privy and a kitchen. The home had been abandoned for many years and needed a complete overhaul. The renovations included completely removing and repairing the pine wood floor and burning a half-inch of paint off the walls that had built up over time. An exterior staircase was taken down and interior stairs put in, allowing access to the upper floor of the home. Previously, a front porch and tin roof had been added to the house by building

on top of the preexisting roof. After the porch and tin roof were removed, the original cypress shingled roof had to be completely redone. An exact replica was made of each individual shingle using similar cypress wood. The entire roof was given an application of a product called kemkote, which was supposed to make the roof termite and fire resistant. Kemkote was developed by a Memphian. Very little is known about this product or if it even worked.

The house's interior was decorated with reproduction Victorian wallpaper similar to the colors and patterns of the original paper used in the 1840s and 1850s. The home was furnished with antiques from the 1850s. A few of the Magevneys' personal possessions were also included in the museum. These include Eugene Magevney's school desk and secretary desk, and Mrs. Magevney's horse-hair trunk, which traveled with her when she came to this country from Ireland. The Magevneys' mahogany dressing bureau, which was used as the altar for the first Catholic Mass in Memphis, was also located in the home. A hand-carved crucifix, found lodged within the walls of the home during the renovation, now hangs downstairs. In 1972, the home was added to the National Register of Historic Places. The following year, the museum was placed under the direction of the Pink Palace Museum. In 1981, one of the exterior buildings, once used as either a stable or slaves' quarters, was renovated for classroom space and public restrooms. Archaeologists also excavated the backyard in the early 1980s. Several items found, such as bottles and china, were put on display in the home's dining room.

Former caretakers and volunteers have often gardened in the backyard. W.L. Barron, a retired truck farmer, served as the home's gardener when the museum was initially opened. During World War II, he planted a small "Victory garden" in the backyard. He later planted a very small cotton patch, only six by six feet, so tourists could see what it looked like. He found that most tourists, many from the North and other countries, had never seen cotton being grown and were fascinated by it. In the early 1950s, Barron grew a dozen tobacco plants from seed. After he cured the tobacco in the old carriage house, the tobacco was used to make three fine cigars.

Home Sweet Home

There have been reports of strange and unexplained activity in the old house for decades. Some former employees felt so uncomfortable in the house that they stayed outside in the yard, only entering the home to conduct tours. Many visitors to the home have walked in and felt so uneasy that they immediately left. One woman left the home in tears because she felt she was in the presence of something extremely unpleasant.

One former employee thought that the activity centered on the large four-poster bed located in the front bedroom. One small girl visiting the house with her mother was seen staring out the window toward the alley between the house and the old St. Peter church. After a minute, she looked up at her mother and asked, "Mommy, who is that man?" The mother and a tour guide looked out the window, but the alleyway was empty. Once, when a group of schoolchildren toured the house, the locked door to Mr. Magevney's old secretary desk opened on its own.

The spirits of children, most likely Mary and Kate, have also been reported in the house. Two little girls have been seen peering out the bedroom windows at night. Volunteers working in the backyard have arrived early in the morning to find a small child's footprints in the garden that were not there when they left the night before. The sound of someone throwing a ball up the stairs and letting it bounce down can be heard on the interior staircase, which was added when the house became a museum.

Over time, the museum's staff, operating hours and funding all began to decline. In 2005, the official announcement came that the Magevney House Museum, along with the Mallory-Neely House Museum, would be closed indefinitely.

THE BURKLE ESTATE

The Burkle Estate, which currently operates as the Slavehaven Underground Railroad Museum, is located at 826 North Second Street. Some Memphians believe that according to folklore, the estate, which was the former home of Jacob Burkle, was once a stop on the Underground Railroad.

The small, one-story white frame house was one of four buildings that sat on five hundred acres, just outside the original city limits of Memphis at Gayoso Bayou. The property was the location of the first stockyards in Memphis and also maintained a bakery. Jacob Burkle was a German immigrant who came to America in the mid-nineteenth century to escape being drafted into the army. In 1854, he married Mary Frecht, and together they had three children. Mary died in late December 1859, and Jacob married Rebecca Vorwort three months later. At the time of his death in 1874, he was survived by two children from his first marriage and two from his second.

One of his daughters, Rebecca, married John Lawless, one of the city's first salesmen, in 1882. His daughter, known to her neighbors as "Mother Becky," lived in the home her entire life. The couple had three sons, John, Will and Fritz, and a daughter, Mrs. Townes Compton.

The Burkle estate now operates as the Slavehaven Underground Railroad Museum. *Photo by Laura Cunningham.*

Home Sweet Home

Those who believe that the home was a stop on the Underground Railroad focus on a trapdoor leading to the cellar with a concrete floor, and brick steps in the cellar, which end at a brick wall. Allegedly there were once tunnels under the house—one under the home's hallway that supposedly led toward the Mississippi River and another that ran along the side of the house. Burkle's granddaughter, Mrs. Townes Compton, who passed away in 1978, was the last family member to live in the home. Some claim that Mrs. Compton told stories about her grandfather hiding slaves underneath the house. Part of the folklore even claims that James Burkle would leave a sack full of gold on a fencepost at the river, and riverboat captains would then pick up the runaway slaves for passage to the North.

The historic marker in front of the home focuses on the home's history as the Memphis Stockyards, with only a brief mention of the persisting folklore involving the Underground Railroad. Opponents of the folklore theory state that there is no documented evidence of an Underground Railroad network existing in Memphis. In addition, there is evidence that Jacob Burkle owned slaves himself. In 2003, a journalist for the *Tri-State Defender* reported that records located in the Shelby County Registers Office showed that Burkle purchased a ten-year-old slave girl named Ann for $875 in 1859.

As the Slavehaven Underground Railroad Museum, the home is furnished with period pieces, artifacts and memorabilia that document the history of slavery and aspects of Memphis history. The museum is run by Elaine Turner and her sister, Joan Lee Nelson. In 1983, the sisters founded Heritage Tours, Inc., which was the first African American tour company in Tennessee.

The house has a long history of being haunted. Doors and windows have been known to open and shut on their own, and strange noises are occasionally heard throughout the building. The Memphis Paranormal Investigations team has conducted investigations in the home and also contributed to the museum by building a memorial garden.

GOING, GOING, GONE

Haunted Endangered Buildings

The Tennessee Brewery, Sterick Building and the Sears Crosstown Building have remained fixtures on the Memphis skyline for over half a century. These once grand architectural treasures have now stood vacant for decades. These three buildings often appear on lists of the city's most endangered buildings and underutilized buildings and even as top Memphis eyesores. The fate of these purportedly haunted buildings remains unknown.

TENNESSEE BREWERY

The Tennessee Brewery, located at 477 Tennessee Street, has stood on the bluffs of the Mississippi River for nearly 120 years. The brewery was originally organized in 1877 as the Memphis Brewing Company under the operation of S. Luehrmann, P. Wahl and H. Leisse. The company served its first beer in June of that year, and sales in August showed that the company was producing 1,842 kegs a month.

The brewery became increasingly profitable, which caught the attention of three men from St. Louis—John Schorr, Peter Saussenthaler and Caspar Koehler. In 1885, the three men purchased the company and the brewery property on Tennessee Street for $18,000 and changed the name to Tennessee Brewing Company. As the company grew, the brewery's size soon became an issue. A first expansion in 1886 added an additional storehouse. In 1890, the building was expanded to the impressive size it is today.

By 1892, the company had increased production to over thirty-six thousand barrels of beer a year. At that time, the company produced three brands of beer: Pilsener, Erlanger and Lager. A fourth brand, Budweiser, had been produced for a brief time but soon disappeared, perhaps because of the Anheuser-Busch Brewing Association's attempts at protecting the name of its signature product. The next year, the brewing company produced Columbian Extra Pale, which was introduced after it won the top prize at the World's Columbian Exposition in Chicago. By winning the contest, it became the only brand of beer in the country to use the name.

By 1900, the brewery was said to be the largest in the South. The brewery also had its own ice plant, which produced thirty tons of ice per day. By 1903, production had increased to 250,000 barrels a year. The brewery also had a fleet of twenty wagons that delivered kegs of beer to saloons throughout Memphis. When bottled beer became popular, the brewery added three bottling machines that produced 1,250 pints an hour.

The Tennessee Brewery, once the largest brewery in the South, was placed on the National Register of Historic Places in 1980.

During Prohibition, the brewery attempted to stay in business by changing its name to Tennessee Beverage Company and began producing "near beers" called Brewette and NIB, which stood for nonintoxicating beverage. After sales proved unsuccessful, the brewery was forced to close. After the repeal of the Volstead Act in 1933, John Schorr's son, Jacob B. Schorr, purchased the building. After refurbishing the machinery and the building, the brewery reverted back to the Tennessee Brewing Company, with Goldcrest Beer as its leading product. In 1938, the brand name was changed to Goldcrest 51, celebrating over fifty-one years in the brewing business. Rising production costs and national competition led to the brewery's closing in 1954. In 1955, Karchmer Scrap Metals purchased the building, using the facility until 1982. The building has changed ownership several times since then but has remained empty.

Whoever the spirits that reside in the brewery are, they appear to be angry. Loud noises, strong enough to rattle windows, can be heard throughout the building. Footsteps can be heard continuing up the stairs even after the person stops walking. Some people have been pinched, touched and even pushed in the factory. Some people believe that the ghosts in the brewery are the spirits of former workers, although one ghost is believed to be the spirit of a boxer. Allegedly, the old building once hosted boxing events. On one occasion, a boxer was badly beaten and later died. His spirit is said to still roam the halls where the events leading to his death took place.

THE STERICK BUILDING

Located at the corner of Third Street and Madison Avenue, the Sterick Building was constructed on land once belonging to Napoleon Hill. Hill's heirs combined their interests in the property into Sterick LLC, a company that owns the land. Charles Niles Grosvenor Jr. helped negotiate a ninety-nine-year land lease. At present, this land lease provides an enormous challenge to any redevelopment plans for the Sterick building. The building will

return to the ownership of Sterick LLC in 2028. Currently, it has proven difficult to find an investor willing to develop the property knowing it will no longer be theirs in 2028.

When it formally opened in 1930, the Sterick was referred to as the tallest and finest office building in the South. The imposing, Gothic-style skyscraper stood 365 feet tall, with twenty-nine above-ground floors. Architect Wyatt C. Hedrick designed the building, which was financed by his father-in-law, Ross Sterling, who would later become the governor of Texas. The building is a combination of the two men's names.

The office building was constructed at an expense of approximately $2.5 million. The lobby's elaborate central chandelier cost $1,350, and all eighteen lobby lights totaled $8,600. The lobby was decorated with pink and black blended marble, and a total of eight high-speed elevators were located on either end. Each of the building's 879 offices was designed with white oak, terrazzo floors and ceiling fans. The building also featured a law library and a women's lounge.

In 1932, only two years after opening, the building was sold at a public auction to the Madison Avenue Corporation for $1.9 million, which then transferred the company to its vice-president in 1950. It sold again two years later to the Mid-Southern Foundation, a nonprofit welfare corporation, for $1.9 million, and in 1956 it was purchased by Lawrence Wien and Associates of New York for $3.8 million. In 1973, the Equitable Life Assurance Society of the United States purchased the building at a public auction for $1.9 million. The next owners, United Property Resources, held a rededication ceremony after it purchased the building in April 1977.

Originally, the building had a green roof, and the façade was left unpainted, exposing the light-gray limestone and granite stonework and concrete panels. The building had nine-feet-tall stone Gothic spires on three floors, which were removed in 1947 due to repeated lightning strikes. It received its first paint job, white, in the 1960s. In 1982, the building was sandblasted and painted pale yellow ("buff"), with dark brown and maroon trim, and the green tile roof was repainted a shade of orange copper. The new paint job sparked a fair amount of public outcry from those who argued that it was not

The Sterick Building, once considered the finest office building in the South, has stood vacant for over twenty-five years.

in keeping with any historical context. The Sterick was added to the National Register of Historic Places in 1978. It became completely empty of tenants in 1987 and has remained empty ever since.

The Sterick Building is haunted by at least one ghost, a woman who committed suicide by jumping off the building to her death. Her dominant father had chosen her fiancé, and the woman was heartbroken because she was in love with someone else. Feeling trapped and not wanting to disappoint her father, she chose to jump off the building to save herself from a loveless marriage.

In 1981, a man did die from falling off the building, fleeing an attempted rape. The man grabbed a woman from the elevator when it stopped on the twenty-third floor, pulling her into a vacant office. Office workers three floors above heard her screams and quickly alerted the building's security department. Security quickly went into action, searching the known vacant offices, which were all unlocked due to the fire codes. They soon caught up to the man, grabbing him, which allowed his victim to escape. He struggled with the guards and was able to escape and take off running. The security team blocked the two exits to the office and later reported that the man began acting wild, like a trapped animal. For some reason, the man broke one of the windows and went out onto the ledge. Witnesses from a neighboring building saw the man clinging to the ledge before falling. Employees on the Sterick's twentieth floor reported hearing him scream as he passed by the window. He landed on the roof of the fourteenth floor, one hundred feet below. Police were able to identify the man through his fingerprints. It is believed that he may have been trying to hide from security out on the ledge and either underestimated the wind or overestimated his ability to hold on.

While the building was still occupied, tenants on upper floors reported hearing screams outside the windows, as if someone was falling by them. Workers who remained in the building after most of the tenants left claimed to see lights on and hear the sounds of people at work in some of the unoccupied offices.

Going, Going, Gone

Sears Crosstown

At 9:00 a.m. on August 8, 1927, over two thousand Memphians patiently waited outside 495 North Watkins as Mayor Rowlett Paine turned a key and threw open the building's doors, officially opening the Memphis branch of Sears, Roebuck & Company. An estimated forty-seven thousand people walked through the doors that day, which quickly established Sears as one of the largest retailers in the city. The massive eleven-story building and seventeen-story tower initially had over 650,000 square feet of floor space. The facility featured a catalogue order plant and distribution center in addition to a two-story retail store. The building also included amenities for its employees, such as a cafeteria and clinic complete with four beds, an emergency operating room and a full-time graduate nurse on duty while the store was open. One of the building's unique features included a seventy-five-thousand-gallon water tank at the top of the tower, which served as part of the building's fire-protection system. The $5 million building was completed in only 180 days. An extension to the Crosstown streetcar line was also laid to bring Memphis shoppers to the building.

The building served as the merchandise warehouse and distribution center for a seven-state region, which included over 750,000 customers. Once the mail-order business began to decline, Sears was forced to shut down its giant warehouses across the country. After several decades serving the Mid-South, the retail store at Crosstown closed in 1983, and a surplus store opened in a portion of the space. The massive catalogue distribution center closed in 1990. The surplus store followed in 1993.

The Art Deco building, once noted for its fine craftsmanship and intricately carved stone ornamentation, is now known for broken and boarded-up windows, rusting doors and even weeds growing out of the sides of the building. While not completely derelict, the building is well on its way of becoming that way soon.

Soon after the building became vacant, vagrants and curious adventurers began exploring. Many people have witnessed doors

slamming and windows shutting in front of them. Mysterious sounds of busy shoppers and escalators have been heard throughout the building. One story claims that the old parking garage is haunted by the ghost of a homeless man who was killed there and buried behind the building.

THE ORPHEUM

S ince the 1890s, there has always been a theatre at the southwest corner of Main and Beale Streets. Currently, the corner is home to the Orpheum Theatre. The Orpheum's predecessor was the Grand Opera House, built in 1890 when a group of twenty-five of Memphis's most prominent businessmen formed an investment group. They each contributed $3,500 and sold bonds to cover the building's remaining $200,000 cost. Their ambition was to give Memphis one of the finest theatres in the country, even building the largest stage outside of New York City. The cornerstone ceremony took place on October 28, 1889, and the official opening night occurred on September 22, 1890. The Grand Opera House struggled financially until finally being taken over by the Orpheum Circuit Company in 1907. Renamed the Orpheum, the structure burned down in 1923.

Architects Rapp and Rapp, a firm specializing in building Orpheum theatres, stepped in to recapture a bit of the theatre's former glory. The New Orpheum lasted from 1928 until 1940, when the Malco Theatre Corporation took over the building. Malco remained until 1975, and then the theatre was converted back into the Orpheum.

The Orpheum Theatre is home to Mary, a little girl that has been roaming its halls for over eighty years. Though a paranormal investigation in the mid-1970s determined that the theatre had at least seven distinct spirits, Mary is the only one most people are familiar with.

The Orpheum Theatre. *Photo by Lela Cunningham.*

Previous management at the theatre tried to keep the ghost stories quiet, claiming that a haunted theatre would be bad for business. For over fifty years, Mary's ghost remained hidden from the general public. Finally, they admitted that people have seen and felt the ghosts since the theatre was built.

Mary is approximately twelve years old with long brown hair worn in pigtails. She is always seen wearing what appears to be a white midiblouse or school uniform with no shoes and black stockings on her feet. Her favorite seat is C-5 in the mezzanine, which is the lowest balcony in the theatre. The chair in which Mary was originally spotted was auctioned off to the Rendezvous in 1982.

Performers at the theatre provide the most frequent sightings of Mary, many of whom have become quite upset after seeing her sitting in the audience. However, Mary has never once been known to disrupt a performance. Mary appears to enjoy the noise and excitement of the theatre, but those who have seen her suggest

The Orpheum

A look inside the Orpheum Theatre.

that she looks terribly lonely, as if she longs for a playmate. Mary is often described as mischievous, a little childish and a bit of a practical joker.

No one is exactly sure who Mary is, how she died or how the Orpheum came to be her home. There are several theories surrounding Mary's death and why the Orpheum became her home in the afterlife. Originally, Mary was thought to have been a possible victim of the fire that destroyed the original Orpheum building, constructed in 1890 and ruined in 1923. However, no lives were lost in that fire.

Some stories have Mary dying in either a streetcar accident or a falling accident in front of the original Orpheum in 1921. Her spirit wandered into the theatre and has since remained. No one will ever know for sure.

In the 1970s, Dr. Everett Lee Sutter brought his continuing education parapsychology class from Memphis State University, now University of Memphis, to the Orpheum. Dr. Sutter was a

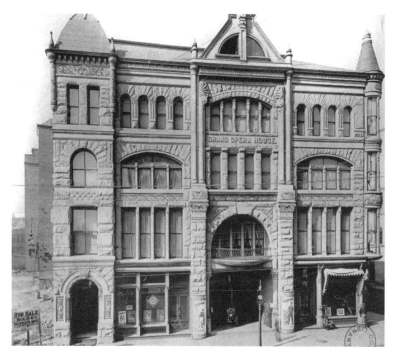

The Grand Opera House, 1895. This theatre once occupied the corner of Main and Beale Streets.

university psychologist who had a long-standing interest in psychic phenomenon. The students used a Ouija board to contact and authenticate the presence of any spirits that might be in the theatre. The class conducted a séance in which they learned that the ghost's name was Mary, she was twelve years old and she had died in 1921 after being hit by a streetcar. She let the students know that her spirit floated into the theatre because she felt it was a happy place. It was also at that séance that the students learned of the other ghosts at the Orpheum.

Mary has always been known as a bit of a practical joker. She has turned lights on and off, slammed doors and even thrown a maid's cleaning tools into the toilet. If people in the theatre call for Mary or make fun of her, she has been known to retaliate. She can often be heard laughing throughout the

entire building. New light bulbs have often been found the next morning twisted loose.

Like many little girls, Mary enjoys hearing the organ being played, and she enjoys the crowds that come only occasionally now to the old theatre. She will often make an appearance in the early morning hours while someone is playing.

Performers have also reported seeing the little girl darting back and forth in the balconies. One story claims that actor Yul Brynner saw Mary on many occasions while rehearsing for the production of *The King and I*. In 1977, the New York company of *Fiddler on the Roof* became certain that the theatre was inhabited by a ghost. They insisted on holding a séance in the upper balcony immediately after their opening night performance.

Over the years, Orpheum ushers, guests, performers and even hard-nosed skeptics have all reported seeing the little girl. Usually, right before she appears, you begin to feel an intense damp cold that reaches through your body. The most "vivid" sighting of Mary came in April 1979. A small group of people were at the Orpheum late at night, listening to Vincent Astor play the organ. Each time Astor played "Never Never Land," the theatre became "deathly cold." Soon, members of the group noticed a faint light darting in from the lobby and down behind the seats in the far back of the theatre. Upon looking out into the lobby, they saw a little girl with brown hair dancing in the distance.

Some people in the group felt compelled to follow her, as if they were in some sort of trance and were being summoned. Several people went into the lobby after her, but by the time they got there, she had disappeared. Immediately, a furious rattling began in the broom closet just off the side of the lobby. The group quickly left to join back up with the others and the rattling stopped. But the little girl reappeared and stayed for over forty-five minutes. The intense feelings of being watched and the icy coldness persisted while the group was at the theatre.

RESTAURANTS, BARS, TAVERNS

EARNESTINE & HAZEL'S

Earnestine & Hazel's, located on 531 South Main, was the former home of a brothel during World War II. The proximity to the train station made it the perfect location for a first-floor drinking establishment, with "anything goes" on the upper floor. Allegedly, multiple deaths are said to have occurred at the bar, including drug overdoses and murders. In the early part of the 1900s, Earnestine & Hazel's was a drugstore. Earnestine and Hazel bought the place in the late 1950s and made it a hotel for traveling passengers, but it was a favored spot among rowdy musicians and bluesmen.

Earnestine & Hazel's has a haunted jukebox, which often plays songs that pertain to conversations that patrons are having in the bar. The upstairs lounge features a piano that often plays by itself and an old claw-foot bathtub in which a prostitute allegedly committed suicide. Ghostly figures have been spotted at the bar in addition to walking through the building at night. The janitor, who comes in every morning from 6:00 a.m. until noon has seen the ghosts of many, many people walking up and down the staircase. He has seen the ghosts of many prostitutes as well.

PEE WEE'S SALOON

Back during Beale Street's heyday, Pee Wee's Saloon was a large establishment that consisted of a saloon, gambling house and rooming house. Legend has it that W.C. Handy wrote "Memphis Blues" at the club in 1900. The saloon bordered a bayou, and many bodies were dumped there after run-ins at the saloon. The owner of Pee Wee's was Virgilio Maffei, an Italian immigrant who arrived in Memphis with only ten cents to his name. Maffei was given the nickname Pee Wee because he stood only four and a half feet tall.

The saloon later became a recording studio. Sound engineers often reported strange, unexplained noises and ghostly sightings. In more recent years, this spot became the location of a Hard

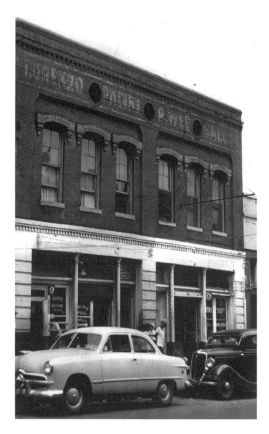

W.C. Handy wrote "Mr. Crump" for Edward H. Crump's mayoral campaign in Pee Wee's Saloon. The song was later renamed "Memphis Blues."

Rock Café. When it came time to build, construction companies simply took the old building that was Pee Wee's and pushed it into the basement.

CAFÉ FRANCISCO

Employees at Café Francisco, located at 400 North Main, were convinced that their restaurant was haunted. What makes this particular haunting unique is a ghost train. As the clock strikes midnight, the sounds of a train whistle can be heard growing louder and louder as it approaches the building. Then, the entire building shakes as if the train is plowing straight through it.

This area of North Main is known as the Pinch District. The name comes from the phrase "pinch-gut," which was used to describe early Irish settlers who moved to Memphis and the way their stomachs were tightly pinched by belts.

Previous owners of Café Francisco, now closed, claimed that the building was haunted by a ghost train every night at midnight. *Photo by Laura Cunningham.*

The Pinch District is no stranger to ghosts. One story alleges that the district is haunted by a woman who was attacked and killed by a group of men in the early 1900s. She now haunts men who are out walking the streets at night.

QUETZAL INTERNET CAFÉ

The Quetzal Café, located at 668 Union, was formerly the location of a tire warehouse. Employees at the restaurant have claimed to see a male ghost who appears to resemble James Dean. He has been seen on the first floor wearing dark pants and a white T-shirt.

Human-shaped shadows have also been seen walking through the building. Motion-activated towel dispensers in the kitchen have been activated when no one else is around. A team from the Memphis Mid-South Ghost Hunters once did an investigation at the building. In one experiment, they played a CD of 1950s Buddy Holly songs, which produced moving shadows on the balcony between the first and second floors. Photos at the restaurant produced bright orbs and other light anomalies.

JUSTINE'S

Justine's restaurant was built in 1843 with handmade bricks from clay removed from the home's basement. The home changed hands numerous times before Justine and Dayton Smith purchased it for their restaurant Justine's. They had recently opened at a nearby location only eight years previous, but the couple fell in love with the home, known as Coward Place, and soon began renovating it for their new location.

In 1958, the couple began renovations on their restaurant. A "fancy" porch, which ran the length of the front for many decades, was removed. Early additions to the house were also removed. Nearly a dozen layers of paint were scraped away.

The restaurant was also known to have a ghost. On many nights, waiters at Justine's would wait until the restaurant's owners left

The popular Justine's Restaurant, now closed, operated in one of the oldest homes in Memphis for nearly forty years. *Photo by Laura Cunningham.*

for the evening before they would head down to the wine cellar. The discreet location was a favorite for playing late-night poker games. One evening, the ghost of Mary Niles Grosvenor, who died in childbirth during the Civil War, appeared at their table. The waiters never played poker in the cellar again.

Janet Smith, daughter of the owners, also witnessed the ghost. One evening, while working in the wine cellar, she felt a presence, only to look up and see a long, dark shadow. She first assumed that it was an employee playing a prank but quickly realized the figure was partially transparent.

Years later, guests would ask if the house had a ghost. While upstairs, Janet had seen a very agitated apparition walking back and forth from one of the party rooms to the ladies' restroom, which served as a nursery during the early 1860s.

AT DEATH'S DOOR

Memphis's Haunted Hospitals

THE OLD VETERANS HOSPITAL

In 1890, W.B. Mallory built a large mansion where Crump Boulevard becomes Lamar. The property was later purchased for the Methodist Hospital of Memphis. In 1921, the Veterans Administration purchased the building for $859,000, creating the first general medical surgical Veterans Bureau hospital in the South. The Mallory home was used as a residence for nurses. The hospital remained active until it was closed in 1958. Baptist Hospital then purchased the facility, and after extensive renovations, the facility, referred to as the Lamar Unit, opened in 1962.

The hospital was abandoned for several years, during which time the ghost stories started surfacing. For quite some time, the building became a haven for drug addicts. The large building was a virtual playground for urban explorers who seek out abandoned structures. The hospital is not only rumored to be haunted by spirits of those who died while in the hospital, but it is also haunted by the ghosts of several drug addicts who overdosed or were murdered while the building was abandoned. People who have been inside have reported bloodcurdling screams, breaking glass and loud slamming noises.

The building has recently been demolished.

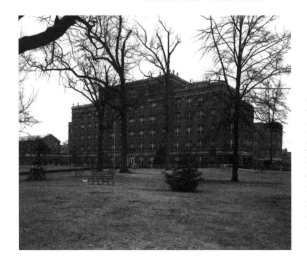

Originally a Veterans Hospital, Baptist Hospital purchased the facility, and after extensive renovations, the facility (referred to as the Lamar Unit) opened in 1962.

KENNEDY ARMY HOSPITAL

For years, there have been rumors of a ghost walking the halls of the WKNO-TV television station, which has been located on the South Campus of the University of Memphis since 1979. In 2006, members of the Memphis Mid-South Ghost Hunters performed an investigation at the television station and recorded several EVPs, or electronic voice phenomena.

The University of Memphis's South Campus was the location of one of the largest army hospitals in the United States during World War II. In anticipation of a large number of war casualties, the War Department began building large-scale hospitals throughout the country. In 1942, Memphis learned that one of these hospitals would be built in the city. The hospital, named for Brigadier General James M. Kennedy, opened on January 23, 1943, and treated forty-four thousand combat veterans over the course of the war. The hospital was located on Shotwell Road, which was immediately changed to Getwell for the sake of injured war veterans being treated at the facility. Originally planned as a 1,500-bed hospital, Kennedy Hospital grew to a capacity of 4,387, becoming the second largest of the army's general hospitals. The hospital in Memphis specialized in neurology, orthopedic surgery, thoracic surgery,

neurosurgery and psychiatry. The Veterans Administration took control of the hospital in 1946, and the property became the South Campus in 1967 for what was then Memphis State University.

UNITED STATES MARINE HOSPITAL

Adjoining the National Ornamental Metal Museum, a collection of buildings sits in a state of dilapidation. This 3.2-acre complex, located at 360 West California Avenue, is the former location of the old United States Marine Hospital.

In 1798, President John Adams signed an act creating the Marine Hospital Service, which was designed to administer aid to sick and disabled seamen. The first of these hospitals in the Mid-South was not in Memphis but rather downstream in Napoleon, Arkansas.

Napoleon was located near the confluence of the Arkansas and Mississippi Rivers. The entire town was destroyed by flooding when the Mississippi changed its course in the late 1870s. At that time, the bricks of the old hospital were brought to Memphis to construct a new hospital here. The site was selected in 1881 at a location called Fort Pickering.

In 1884, working through the U.S. Public Health Service, the government opened the U.S. Marine Hospital. The original hospital complex consisted of six buildings. These included a stable, a surgeon's house, a laundry/dining room and two wards, connected by covered porches to the executive building. The wards and stable, all frame structures, were demolished in the 1930s. The largest building is a brick, three-story, Neoclassical structure, built in 1936. The surgeon's quarters survived until 1964. The last two surviving buildings from 1884, the laundry/dining facility and executive building, are listed on the National Registry for Historic Places.

In 1951, the facility's name officially changed to the United States Public Service Hospital. The hospital closed in 1965. In 1970, the property was divided. The federal government retained the eastern portion of the site, and the City of Memphis acquired the western side. The City of Memphis leased its side to the Ornamental Metal Museum. In July 1976, the Metal Museum obtained a five-year

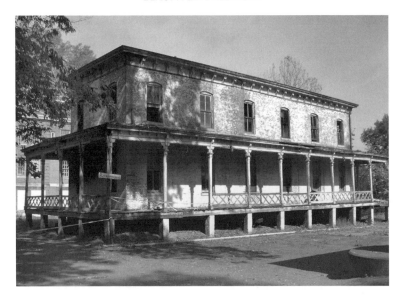

One of the two surviving buildings from the original United States Marine Hospital, constructed in 1884. *Photo by Laura Cunningham.*

lease. The museum officially opened to the public on February 5, 1979. The museum has turned the three buildings on its side of the complex into the main museum, a library and residence and housing for visiting artists. The museum itself was built in 1937 as the nurses' dormitory. In 1992, the City of Memphis gave the museum a twenty-five year renewable lease.

Urban legend has it that spirits of the dead soldiers haunt the museum grounds. Interns at the metal museum have also reported seeing a man in a wheelchair on the second floor of one of the old white buildings from 1884 that were once part of the hospital. Another intern who lived in the dorms kept waking up every night between 3:00 and 4:00 a.m. when all the items on her bathroom shelf repeatedly fell to the floor. After the room was painted, the occurrences stopped. The most common sightings at the Metal Museum are of nurses from the late 1880s. Ghosts and unexplained sounds and sightings have occurred all throughout the former hospital and at the park across the street.

PHANTASMS IN THE PARKS

Overton Park

Rainbow Lake, located in Overton Park, is haunted by the ghost of a mysterious woman in a light blue dress who is often seen with her arm outstretched as if asking for help. She vanishes before anyone can approach her. Witnesses have guessed her age as mid-thirties, and she is usually spotted walking around the southern edge of the lake at night. Some people who have seen her claim that she actually rose out of the lake itself. Frequent visitors to the park have also reported blue streaks of light in the woods next to the lake. Supposedly, a woman was raped and stabbed in Overton Park in the 1960s. Her body was found the next morning in the lake. Many believe that the lady in blue is the woman's ghost, unable to rest until her killer has been caught.

Overton Park, located at 1928 Poplar Avenue, is a 342-acre park located in the Midtown section of Memphis, which serves as a recreational and cultural center in the community. The park includes a 175-acre old-growth forest, the Memphis Zoo, the Brooks Museum of Art, Memphis College of Art and the Levitt Shell outdoor amphitheatre.

After the success of New York City's Central Park, designed by Frederick Law Olmsted Sr. and his partner Calvert Vaux, a movement began across America to establish large pastoral parks in major cities. In 1898, the Memphis mayor and legislative council established a committee to create a park system for the city. The

Rainbow Lake, located in Overton Park.

Olmsted Brothers firm in Massachusetts was contacted for advice. Landscape architect John C. Olmsted, who was now in charge of the firm, responded to the Memphis committee and offered several suggestions that led to the establishment of the park commission.

One of the first tasks of the board of park commissioners, established in 1900, was the purchase of property on the far eastern edge of the city, known as Lea's Woods. It had once been part of a large five-thousand-acre tract of land owned by John Overton, one of the three founders of the city of Memphis, and had been willed to one of his grandsons, Overton Lea. After the city purchased the land, the park was briefly named East Park until it was suggested it be named in honor of the former landowner, John Overton, who had also provided the city with a system of parks and promenades when designing the city layout. The commission also hired landscape architect George E. Kessler, who served as the consulting architect from 1901 to 1914.

Construction began on Rainbow Lake in January 1929. The two-acre lake was two to three feet deep and built at a cost of $6,000. That year, the lake became the focal point for the largest electric fountain in the country, a gift from the Memphis Electric League. Nearly four thousand people came to the park to see its dedication as part of Light's Golden Jubilee, a celebration of the fiftieth anniversary of Thomas A. Edison's invention of the electric light

bulb. The fountain projected arcs of water sixteen feet into the air, illuminated by twenty-four layers of colored lights, which reflected on the surface of the lake, inspiring its name. In the summer of 1933, the park began illuminating the lake with the colored lights three nights a week. On Sundays, the lake was lit from 8:00 p.m. to 10:00 p.m. and on Tuesdays and Thursdays from 8:30 p.m. to 9:30 p.m.

In its earliest days, Rainbow Lake served as a hatchery for bass. The Izaak Walton League was responsible for stocking the lake. In 1932, over six thousand baby bass were hatched and raised in the lake before being distributed to over a dozen lakes and fishing holes in the Mid-South area. In 1934, a horrible accident resulted in the death of all the fish in Rainbow Lake. The Izaak Walton League blamed the deaths on the Memphis Park Commission for putting copper sulfate in the water to kill the algae where the mosquitoes bred. They felt that it would not normally have harmed the fish, but the water level was low. A sanitation engineer with the city health department claimed that it was possible the fish died from suffocation due to lack of oxygen in the water, and the dying plant life further depleted the oxygen level.

Although the fountain and lights disappeared, the lake still remained one of the most popular spots in the park. In 1981, the lights, which had not worked in years, were replaced with flowers and the chain-link fence that once protected the lighting system was replaced with trees. By this time, the lake's lining became cracked and unable to hold water. Park commissioners thought it might be for the best if the lake was filled in, but the public would not hear of it. They wanted to preserve the lake. In 1991, the park commission spent nearly $400,000 restoring and enlarging it.

LIBERTYLAND

In the early 1970s, the City of Memphis provided money to build an amusement park at the location of the Mid-South Fairgrounds, 940 Early Maxwell Boulevard. Libertyland held its grand opening celebration July 4, 1976. When the twenty-two-acre theme park

opened, it had fourteen rides, ten games, seven dining areas, sixteen food carts and three stages that featured five stage shows. The park was designed with three sections that represented different eras of American culture: Colonial Land, Turn-of-the-Century Land and Frontier Land.

For years, stories have circulated that the amusement park's Grand Carousel was haunted. According to stories, soon after the amusement park opened, a child riding the carousel let go of his balloon, and it became trapped at the top of the ride. When a kind operator went to retrieve the balloon for the child, he somehow became trapped in the ride's gears and died. His spirit was said to haunt the carousel, and his presence was often felt throughout the park.

Libertyland's Grand Carousel, built in 1909, originally operated at Forest Park in Chicago. After a fire at the Chicago park damaged the ride, it was returned to the Dentzel Carousel Company to be refurbished. The carousel found a new home at the Memphis Fairgrounds Amusement Park in 1923.

The carousel was all hand carved with forty-eight horses, a pair of dragon chariots, mirrors, clown heads and cherubs. Before the opening of Libertyland, $160,000 was set aside to restore and move the Grand Carousel to a new location, roughly sixty feet away from its original spot. Over twenty-one layers of paint were stripped away from the horses to expose the original wood. Missing ears, hooves and decorations were all replaced. Each horse was then repainted by hand to match the carousel's original colors. A new band organ was installed, replacing the original band organ, which had previously been stolen and replaced with recorded music. In 1980, the carousel was placed on the National Register of Historic Places. The theme park remained open for nearly thirty years before closing its doors for the last time on October 29, 2005.

What many people don't realize is that the carousel ghost story is actually true. Libertyland had been open less than two months before it suffered a horrible tragedy. Seventeen-year-old assistant carousel operator Mike Crockett died after getting caught in the main gear of the ride. Crockett used a stepladder to climb approximately four feet before his clothes became caught, and he was crushed by the gears. He was found hanging from a beam inside the main gear housing.

The Grand Carousel at Libertyland. The carousel has been located in Memphis since 1923.

Immediately following the accident, no one was quite sure why Crockett was in the middle of the ride. Homicide officers believed that he was trying to reach a balloon that had escaped from a small child riding the carousel. After the accident, a balloon did escape from the top of the mechanical area of the ride. Libertyland officials believed that the officers' balloon theory was only speculation, and the true reason Crockett went into the center of the ride may never be known.

In 1981, a $2 million lawsuit against the Mid-South Fair resulted in a mistrial after one week of trial, because Circuit Court Judge William O'Hearn felt that his docket was too crowded and the jury term in his court was ending. The lawsuit alleged that Libertyland was negligent because there were no protective devices to keep someone away from the gears.

Mike Crockett was a member of Bountiful Blessings Temple of Deliverance, where his father served as pastor. He would have been a senior at Hamilton High School, where he ran track and played football.

These horses on the Grand Carousel were hand carved by the Dentzel Carousel Company, 1954.

CHICKASAW HERITAGE PARK

The eleven-acre Chickasaw Heritage Park is located across the street from the National Ornamental Metal Museum and the abandoned Marine Hospital. The park is also located just eight hundred feet from the Mississippi River. The park has two historic Native American earth mounds with a modern-day neglected outdoor basketball court between them. During the Civil War, this was the location of Fort Pickering. In 1863, the westernmost mound, the Chisca Mound, was hollowed out and used as an artillery redoubt and magazine. Ammunition was stored in a bricked bunker dug into the mound's side.

Originally, the location was Jackson Mound Park until it was purchased in 1913 and renamed De Soto Park in honor of Hernando de Soto. Previously, the park was the location of the village of Chisca, which was also the name of the village's leader.

View of the Mississippi River from Chisca Mound. Once the location of the fortress of Chief Chisca of the Chickasaw, the mound was used as a four-gun artillery redoubt and magazine during the Civil War.

The park and the abandoned Marine Hospital across the street are considered to be some of the most haunted spots in the entire city. It is rumored that the ghosts of dead soldiers can be seen walking the grounds at night.

ST. PAUL'S SPIRITUAL TEMPLE

"Voodoo Village"

At the end of a dead-end street called Mary Angela Road, located in South Memphis, one will find a collection of houses, small buildings and peculiar artwork completely fenced in, most likely to prevent the constant onslaught of onlookers from trespassing. People come from all areas of Memphis to look at this property owned by Wash Harris. Most Memphians refer to the location as "Voodoo Village," but Harris's name for his property and collection of large, colorful wooden symbols was St. Paul's Spiritual Temple.

The name "Voodoo Village" was given to the Harris's compound by white Memphians in the early 1960s. Harris and his property first gained public attention after altercations between white youths and African American residents resulted in police arrests several times each year. Even though local newspapers did not start covering the incidents until the 1960s, residents on Mary Angela Road were reporting being harassed on a regular basis as far back as 1951.

Incredible legends and tales are what bring Memphians to this isolated road. Allegedly, there is something much more sinister than a church service going on at Harris's Spiritual Temple. Reports of the ghosts of human and animal sacrifices, walking dead, bizarre rituals and various forms of black magic were said to take place behind the iron gate. These rituals were rumored to be reminiscent of African voodoo mixed with Freemasonry.

For many Mid-South locals, it became a rite of passage to go to the street at least once. Rumors flew that if you drove down the street, residents would come out of their homes and push an old abandoned school bus into the road, blocking your exit.

Tradition also held for no photographs to be taken of the Village or of the residents. Not only were you expected to be chased while having rocks and sticks thrown at you, the photos were also rumored to reveal the ghosts of all the people who had been killed at the Village over time. The photos may reveal the true appearance of the villagers, old and decrepit, only being kept alive by Chief Wash Harris's supernatural powers.

In reality, none of these stories is true. However, in a rare newspaper interview with Harris on July 14, 1984, *Commercial Appeal* reporter Williams Thomas wrote, "There is little doubt that these sprawling acres contain some of the most closely guarded folk secrets in the Mid-South."

"Chief" Wash Harris was born in Sardis, Mississippi, and began practicing faith healing when he was just seven years old. Harris was the founder of St. Paul Spiritual Holy Temple and served as its pastor for forty-nine years before dying of a heart attack in 1995 at the age of eighty-nine. According to his obituary, Harris left two daughters, two sons and seventy-one grandchildren and great-grandchildren. As a leader in his church, Harris held the title "doctor" and also served as president of the "Indian Medicine Company." His wife, Sarah Harris, served as his nurse and a teacher in the church. She also helped screen the many visitors to his complex.

Harris was a tall, thin man, self described as part African American, part Chickasaw and part Cherokee. He always wore a pair of white suspenders attached to baggy blue pants that dragged the ground. Rings covered each of his fingers, and he proudly wore a large collection of his Masonic pins across his shirt. Harris prided himself on being a thirty-third-degree Mason and often commented that you would have to be in a lodge in order to understand and truly appreciate the artwork he created on his property.

Harris owned two acres of property adjacent to his home at 4596 Mary Angela Road. The barbed wire fence surrounding the property was painted silver in addition to one small building on the property covered with long spikes.

One of the small houses on Harris's property served as the healing office. Harris's sessions with patients consisted of introductions and

prayer, followed by directions to wash the soul and come back in two weeks. As a "doctor," Harris gave a prescription for washing the soul before any other treatments could be given, regardless of the ailment—washing the soul required three baths per week at the same time of day, using a cup of salt, a half gallon of red vinegar, a small box of baking soda and one cup of graveyard dirt. The patient was to bathe with a white towel and repeat the Lord's Prayer. To cleanse internally, he required the patient to drink a cup of sage tea daily and eat a raw egg with a tablespoon of olive oil.

When the patient returned two weeks later, he was told to continue taking the cleansing baths using graveyard dirt, but now the dirt must come from the middle of the grave, about a half-foot deep. The patient was also reminded to refill the hole. Harris's medical services came with a fee; patients were asked to give a donation according to how much they felt they had been helped.

To the left of the healing office was a small building that served as a temple. Inside, the ceiling, floor and walls were covered with colorful pieces of satin; over seven thousand yards of white silk cloth were also used. The temple was also filled with other symbols and dolls, illuminated by tiny electric lights.

In 1961, Harris's church, St. Paul's Spiritual Temple, had sixty members who wore satin robes and caps to worship. Harris never explained his artwork to anyone. In a 1984 interview with the *Commercial Appeal*, he stated, "It is the work of one man, and don't nobody know what it means but me. People are always coming here trying to get me to talk about it, but I don't discuss it with anyone. If I give it away what have I got?"

On Harris's property, he included dozens upon dozens of elaborate, interesting, colorful pieces of artwork. He used vibrant colors such as pink, red, yellow, blue and orange. He filled his property with symbols like bursting stars, rockets and crescent moons. Harris also had several collections of dolls and other religious symbols displayed in glass containers on towers.

Also on the property were large-scale replicas of scenes from the Bible, such as the birth of Jesus, a fifty-foot beam depicting the pathway to heaven and an eight-foot-tall candle. Harris's artwork and sculptures, deemed strange by outsiders, only added to the

St. Paul's Spiritual Temple has been referred to as "Voodoo Village" since the 1960s. *Courtesy of the Mississippi Valley Collection, University of Memphis Library.*

belief that something unnatural was going on behind the fence.

It was in the 1960s when Harris began having trouble with the law. In 1961, Harris was fined $100 for practicing healing arts without a license. In 1967, he was arrested and fined again for the same charge. In 1969, Harris was arrested and charged with violating the age of consent with a fourteen-year-old girl. In 1970, he was charged with negligence and medical malpractice in a circuit court following the death of an eighteen-year-old boy whom Harris had been treating for stomach problems. After these incidents, Harris became more secretive.

Although most incidents on the street occurred in the mid-1960s, in a 1983 *Commercial Appeal* article, residents reported that they were still being harassed three or four nights a week by carloads of gawkers. The heaviest traffic occurred from Thursday to Sunday, between 11:00 p.m. and 1:00 a.m. The Darwin Church of God in

The mug shot of "Chief" Wash Harris. *Courtesy of the Mississippi Valley Collection, University of Memphis Library.*

Christ, also located on Mary Angela Road, was often the target of vandalism, surviving two firebombing attempts. The church had no connection with Harris.

For years, disputes on the street have resulted in police arrests. Residents have been arrested for blocking the road with concrete blocks, railroad ties and other obstacles and also attacking people who claimed to only be sightseeing. The police often maintained a patrol outside the compound after reports of bottles being thrown at houses and gasoline being burned in the street.

ELVIS HAS LEFT
THE BUILDING

For reasons that may never be known, Elvis Presley has never truly been allowed to die. Elvis Presley came into this world on January 8, 1935, in Tupelo, Mississippi, and on the afternoon of August 16, 1977, he made his final exit. On that day in August, the Memphis Fire Department responded to an emergency call at 3764 Elvis Presley Boulevard. Presley was rushed to Baptist Memorial Hospital, where he was declared dead at only forty-two years old. The entire city was in a state of shock. All city buildings immediately lowered their flags to half-staff as tens of thousands of fans flocked to the city in mourning.

Despite the questions regarding how exactly Elvis died, no one close to him ever expressed doubt that he was, in fact, deceased. However, almost immediately, rumors began to circulate that Elvis was not actually dead. Many who saw Elvis's body in his coffin at Graceland commented that it more closely resembled a wax dummy than a human figure. Soon, seemingly ordinary people began reporting sightings of Elvis all across the country. The idea behind the sightings was that Elvis had become fed up with his life of fame and faked his own death in order to live a simpler life. Although sightings of a live Elvis began the day he died, they did not receive widespread public attention until 1988, when tabloid newspapers picked up a story of a 1987 Elvis sighting by Louise Welling in Vicksburg, Michigan, just outside Kalamazoo.

At some point, people began to differentiate between live Elvis sightings, where Elvis is believed to be living under an assumed

identity, and sightings of Elvis's ghost. For years, tabloids fed rumors of both live Elvis sightings and those of his ghost. The *Weekly World News* has reported that a Vatican exorcist was needed to remove the ghost of Elvis from a nine-year-old boy's bedroom. His mother supposedly brought dirt back from a visit to Graceland and accidentally spilled it in his room, which is how Elvis followed her home. The *Weekly World News* has also attributed Elvis's ghost with saving several teenagers from drug addiction. His spirit appears to young people fond of his music, usually when the person is alone. According to stories, a passionate Elvis provides a message of hope and speaks on the dangers of what drugs can do to your body. The ghost keeps reappearing until the drug addiction has been conquered.

Elvis's ghost sightings serve a different purpose than live sightings. The ghost of Elvis will appear to his devoted fans going through personal struggles, providing them with sound moral advice and a sense of hope and compassion. In a sense, the ghost of Elvis has become an American folk hero. Raymond A. Moody Jr. writes about several Elvis ghost sightings in his book *Elvis After Life*. Included in his collection are the stories of Claude Buchanon and Jack Matthews.

Farmer Claude Buchanon knew Elvis, who had visited his rural Tennessee farm twice. On the afternoon Elvis died, Buchanon was out on a ridge, tending to an injured animal. He happened to look down the hill and saw Elvis, surrounded by a blue mist, walking up the hill toward him. Buchanon, quite surprised that he hadn't seen Elvis driving up the road, called down and asked what he was doing out there. Elvis replied, "I've come to say goodbye for a while, Claude." Just then, Claude's wife came outside and yelled to him that they just announced on the radio that Elvis had died. Claude couldn't sleep for the next two nights, confused as to why Elvis came to him, since he was not one of Elvis's closest friends.

In December 1980, truck driver Jack Matthews believed he saw Elvis one night on the highway, one hundred miles west of Memphis, and even gave him a ride. Matthews had stopped for fuel that evening, and as he was preparing to get back on the road, he noticed a man walking down the old highway, carrying a wool jacket and with a bundle under his arm. When Matthews asked

him where he was headed, he said he was headed to Memphis to see his momma and daddy. Matthews felt bad for the man, walking through the dark countryside, and offered him a ride.

During the ride, the two men discussed the music they liked and cars. The hitchhiker told the trucker that he owned several Cadillacs, but of course Matthews didn't believe him. They were getting along quite well, and Matthews felt comfortable enough to share his problems with alcohol. The young man understood and related how he had battled painkillers and sleeping pills. As they drove closer to Memphis, more lights on the road revealed that the hitchhiker looked familiar to the trucker. He told the trucker his address, which was Elvis Presley Boulevard. At that point, Matthews realized he had never introduced himself. After he did, his passenger replied, "I'm Elvis Presley, sir." Elvis asked to be let off at a certain street, and the trucker did as he was asked. Matthews had never been to Graceland before, but he went back two weeks later and realized that it was just down the street from where he had let his passenger out.

In an interview before her death in 2000, Elvis's former cook, Mary Jenkins Langston, admitted that she had been haunted by Elvis since his death in 1977. Langston served as the cook for Elvis and his family from 1966 until he passed away. Of particular interest is how he appeared to her by returning to haunt the bathroom in the house that he bought her. She would often hear him banging around in the bathroom.

Another local woman claimed that Elvis once possessed her television set. She also believed that a stain on her back patio door was the exact image of the King. Elvis has also been seen walking down several Memphis streets; one local resident even went so far as to say that Elvis's ghost, or one that looked very much like him, walked right through her.

At least three of Elvis's homes in Memphis have held the reputation of being haunted by his ghost. Elvis once lived at the Lauderdale Courts, which were built in 1938 and never refurbished. In 1994, the Memphis Housing Authority declared the complex unsalvageable, and it was set for demolition. That day never came, and the entire complex was refurbished and reintroduced

Sun Studio.

as Uptown Square. In 1995, Elvis's old apartment was the home to Ms. Annette Neal. The *National Enquirer* once published a story about the apartment, with Ms. Neal's consent, under the headline, "Elvis's Ghost Haunts Boyhood Home." Elvis's house on Audubon Drive also had the reputation of being haunted by his ghost. His last Memphis home, Graceland, sits on the former five-hundred-acre farm that once belonged to S.C. Toof, pressman for the *Memphis Daily Appeal*. Toof's daughter, Grace, inherited the property, and family members began referring to the farm as "Graceland." The house on the property was built in 1939 as a country home for Dr. and Mrs. Thomas D. Moore. Mrs. Moore was a descendent of the Toof family. Elvis kept the home's name when he purchased it and an additional thirteen and three-fourths acres in 1957. In June 1971, the stretch of Bellevue that ran southward from South Parkway was renamed Elvis Presley Boulevard. Visitors claim that their photographs capture his image peering out of the upper-floor windows or his presence appears in numerous orbs that appear in the basement rooms.

Several of Elvis's old haunts, such as the current Sun Studios and Sam Phillips Recording Service, are known to have ghosts. At the Sam Phillips Recording Service, many believe that it is the ghost of Dewey Phillips, the WHBQ-AM disc jockey who first played Elvis's "That's All Right, Mama." But many others believe that they can feel the presence of Elvis.

THE SUBURBAN GHOSTS

BARTLETT

In 1859, Major Gabriel Matson Bartlett donated three hundred acres surrounding his property on Stage Road to build a school, church and a Masonic Lodge. After the Civil War, the small settlement, then known as Union Depot, decided to incorporate. In 1866, the community was named in honor of Major Bartlett, who also became the town's first mayor.

The Singleton Community Center, located at 7266 Third Road in Bartlett, is home to the ghost of a little girl given the nickname Mary. Mary has been making herself known at the center for over twenty-five years. The community center lot was the former location of Ellendale Elementary. From the late 1800s until 1918, the Ellendale school was a simple frame structure located at the corner of Memphis-Arlington Road and Appling. In 1918, a brick schoolhouse was built, and a new wing added to it in 1961. The building was closed in 1976. In 1983, the City of Bartlett purchased it and renovated it as the Singleton Community Center, named in honor of Sergeant Walter K. Singleton, a recipient of the Congressional Medal of Honor.

Mary is approximately ten years old, with brown hair, and wears a pale, old-fashioned flowered dress with a white sweater. The first report of Mary occurred in 1986. Late one night, as office employees were closing the building for the evening, a small girl appeared seemingly out of nowhere and asked to call her mother.

As the worker reached for the phone, she looked up to see that the little girl had vanished. The employee checked the hallway and then realized that she had never heard anyone enter or leave the office. Mary has since appeared several more times, again asking to phone her mother.

A maintenance worker once heard Mary as he was cleaning the restrooms. He called in to the room to see if anyone was inside and was quite surprised to hear the voice of a small child answer "No." Upon investigation, he found the restroom empty. After the worker's experience with the ghost, another employee had the same experience a few months later. Mary has also made appearances on the upper floor of the center and in the downstairs auditorium kitchen. Unexplained incidents at the community center such as flashing lights, slamming doors and windows opening on their own have all been credited to Mary. While walking through parts of the building, visitors have suddenly experienced a cold, damp chill. Those who know about Mary recognize this as a sign that she is nearby.

Nobody knows who Mary might be or why she so desperately wants to phone her mother. A former teacher from Singleton's days as an elementary school offered an explanation. A student at the school was killed while on vacation, and her picture hung in the auditorium for years. There is a certain sadness surrounding Mary, the ghost of a little girl who misses her mother.

Another haunted location in Bartlett is the Blackwell House. Constructed in 1869, the home is located at the corner of Sycamore View and Blackwell Street. Dr. Nicholas Blackwell lived in the home until his death in 1910, although many believe that Dr. Blackwell never left.

Dr. Blackwell was the son of General Nicholas and Sarah Blackwell. He attended college at Union University in Murfreesboro, Tennessee, and completed his medical degree from Jefferson Medical College in Philadelphia. During the Civil War, he served as a captain with the Forty-third Mississippi Regiment. After the war, Dr. Blackwell moved to the Bartlett area, where he became a top physician and land developer. Dr. Blackwell would become an important figure in Bartlett's history, serving as the first alderman and the second mayor.

In 1866, Dr. Blackwell married Lucy Virginia Ward, daughter of one of West Tennessee's earliest settlers. The couple had one child, their beloved daughter Willie Bugg Blackwell. Mrs. Blackwell died when Willie was still very young, and Dr. Blackwell moved his niece, Amanda Duncan, into the home to care for his daughter. In 1917, the Nicholas Blackwell High School opened on land donated to the city by the Blackwell family. The school would later change its name to Bartlett High School.

Allegedly, the ghosts of both Dr. Blackwell and his wife have been seen walking through the old house late at night wearing Sunday dress clothes. When lights begin flickering in the house, it's usually a sign that Dr. Blackwell is close by. One story often passed around claimed that a previous homeowner turned a lamp off before bed only to wake up with the light back on. The light was turned back off and then unplugged. When the family woke up again later in the night, they found the light back on and still unplugged. As they commented on this strange occurrence, the light bulb exploded. Some say that Dr. Blackwell affects the lights because he never allowed his daughter to sleep without one.

COLLIERVILLE

The Greenlevel House, located on eleven acres five miles north of Collierville, was built in the late 1820s by John Overton, one of the three founders of the city of Memphis. Overton died in 1833, most likely never seeing the construction to completion. Overton's daughter, Ann, and her husband, Robert Brinkley, inherited the home and property. In 1844, the couple sold the home to Bennett Bagby and his wife, Frances Leake. The couple lived there for six years before selling it to Frances's brother, Dr. Virginius Leake, in 1850. Dr. Leake and his wife, Martha, had five children: Elgin, Millard, Tingnal, Nellie and Mary.

During the Civil War, Greenlevel was converted into a makeshift Confederate hospital. After the Battle of Shiloh in 1862, wounded soldiers were put on a train and dropped off at various towns on the way to Collierville. At least 119 soldiers

reached Collierville and were loaded into wagons and taken to Dr. Leake's plantation for treatment. Soldiers were also cared for in several homes within town.

The upstairs hallway of the home was used for surgery. Bloodstains still remain on the poplar floor no matter how many times the floor is washed. One story claims that the blood spilt on the floor belonged to a soldier who died during a rainstorm. Every time it rains, the stain becomes more visible. Legend also has it that at least four Confederate soldiers are buried near the house, although there are no grave markers. Many more men had their arms or legs amputated at Greenlevel. The dismembered limbs are buried there as well. Some say it is the ghosts of these soldiers that haunt Greenlevel; others believe it is Dr. Leake's daughter Mary, who died of pneumonia about 1871 when she was just fourteen years old. Dr. Leake died of a heart attack in 1873, six months into his term as state senator. However, Leake family legend suggests that Virginius died of a broken heart.

Eventually, the home was abandoned for many years but remained in the Leake family before being sold in the 1960s. The new owners, the Barzizza family, restored the home, which had been badly neglected through time. The home was sold to the Cottam family in 1986 and placed on the National Register of Historic Places the following year. The Cottams eventually sold the home to its current owner, State Senator Mark Norris.

Although it is common knowledge among Collierville residents that the old home was haunted, former owner Don Cottam preferred the term "unexplained phenomena" when referring to his home. The very first day the family moved in, Cottam saw what appeared to be a young girl out of the corner of his eye. She appeared to be five feet tall and wore a tan dress with a wide-brimmed hat. Six months after the family moved in, Leake family relatives gave the new homeowners portraits of Dr. Leake's family. Don Cottam immediately recognized Mary Frances Leake as the girl he saw that first day.

On more than one occasion, Cottam experienced things he could not explain. Once, while working at the top of a ladder, he felt someone tap him three times on his left shoulder. He was not

the only family member that experienced strange happenings. His wife, Dyann, once heard the sounds of a man's loud, heavy footsteps climbing the stairs; eventually these footsteps were heard wandering the halls of the entire house. The couple's son once became terrified after hearing a voice scream his name in his ear. Soon after their son's experience, the incidents started to escalate. During several evenings, at exactly 2:15 a.m. the silverware drawer in the kitchen would crash to the ground. Don Cottam would come downstairs and put the drawer and silverware back in place. Then, at 3:15 a.m. the same thing would happen again.

One night, Don and his wife kept hearing footsteps and the sounds of a chair scraping along the floor coming from the bedroom that their two sons shared. Each time they went to investigate, they found that nothing had been disturbed. The next morning, both of their sons separately asked their father what he had been doing in their room moving furniture in the middle of the night. After living in the home for two years, the Cottams had a Catholic priest come to the home and bless it by sprinkling salt and performing a prayer service. Afterward, the family noticed a drastic difference in their home. It was finally becoming quiet.

Local legend says that the home became haunted while the Leake family still lived there, immediately after the war. Another story claims that a former neighbor of Greenlevel went crazy and killed her entire family and herself in a planned house fire in order to escape the ghosts of the plantation.

Almost everyone who has had some contact with the home has either seen or felt something they couldn't explain. Perhaps one should expect that in a house that has seen that much suffering.

GERMANTOWN

In Germantown, there is a narrow, winding, tree-lined road called Callis Cutoff. The street, located just north of Winchester Road, connects Hack's Cross Road on the east to Germantown Road on the west. The street is named after the large Callis plantation which once occupied the land.

Cassius Marcellus Callis, born on June 8, 1843, was one of the earliest settlers in Germantown. He was a large local landowner, owner of a cotton gin and an early lumberyard. He also once owned the largest and most successful store in Germantown. Callis died in 1925.

For many local teenagers, it became a rite of passage to drive down the street soon after their sixteenth birthday. Brave teens also dared one another to walk the street alone at midnight. The lack of streetlights on the road and the street being too narrow for two cars to pass each other, forcing one to pull off the road, only added to the thrill.

Elaborate stories were passed around regarding the street's history. Some say that in the 1920s Memphis mobsters took people out to the street to have them killed. Others believe that in the 1960s it was used for devil worshipping, witchcraft and human and animal sacrifices that have continued on the street to present day. At one end of the street, a single house has stood alone for decades. One story claims that the homeowners' children went missing, believed to be the sacrificial victims of Satanists. According to the story, the mother always left the porch light on in the hopes that her children would find their way back.

Another story involving the house claims that the homeowner had a teenage child who died in a car accident on one of the steep turns. This mother, too, keeps the porch light on hoping her child's ghost can find his way home.

Anyone who drove or walked the street in the early to mid-1990s can verify that some type of unusual activity was occurring on the street, with the heaviest activity focused at the widest curve in the road, located at the road's halfway point. Pentagrams and disturbing graffiti were scrawled all across the street, often with glow-in-the-dark paint. Black garbage bags swarming with rats and animal carcasses have also been seen. In September 1996, an unexploded pipe bomb wrapped in black electrical tape was also discovered in the weeds just off the side of the road.

Many people brave enough to travel down the road often realized that they were not alone. Many people have claimed to have driven up to people in the deep of the forest wearing cloaks and white face

paint. Flashlights and whispers have been detected in the woods by those walking or driving with their windows down. Some people have experienced motorists lying in wait with their headlights off; when a car approaches, they turn their headlights on and come speeding down the street toward the unsuspecting driver, forcing him to run off the road to avoid a collision.

In recent years, the land nearest Hack's Cross Road has been developed into residential housing, but any further development of the area has been flooded in controversy regarding land-use policies.

MILLINGTON

While "Herky" may not be a familiar name to most people, students at Millington Central High School know the name quite well. "Herky" is the nickname given to the school's ghost, believed to be a girl who hanged herself in the former girls' gymnasium, which is currently the school's auditorium.

Stories surrounding Herky claim that she is responsible for flipping chairs, turning lights off and on and even hitting people with boards. On one occasion, the auditorium director turned off all the lights after play practice and left out a few paint cans. When he returned ten minutes later, all the lights were back on and paint was splattered all over the walls. One story often told claims that during a performance, the play's lead actress left the stage screaming because she saw the figure of a girl hanging from the ceiling. Generations of MCHS students have a Herky story, and there is typically at least one sighting each school year.

Millington is also home to a large facility often referred to as the Haunted Smoke Stacks. Alternately called the Memphis, or Millington, Ordnance Plant, this large factory manufactured munitions for the Allies during World War II. In 1940, the Anglo-French Purchasing Board formed the Tennessee Powder Company, which purchased six thousand acres ten miles north of Memphis to build a $20 million facility.

Eight artesian wells were drilled to supply twenty-two million gallons of water per day to over one hundred buildings. Highway 51

was enlarged to a four-lane highway from Memphis to the Tipton County line in order to accommodate employee traffic. E.I. Du Pont de Nemours & Co. oversaw both construction and operation of the Tennessee Powder Company's facility.

Once open, the plant maintained a round-the-clock schedule for 871 days, excluding Christmas Day 1942. In May 1941, the United States government acquired the plant and changed the name to Chickasaw Ordnance Works. By late 1944, the plant employed over eight thousand women. After the war, the plant was deemed too dangerous for a possible conversion to civilian use, and it was deactivated in 1946 and dismantled.

The property is now rumored to be haunted. Numerous tunnels ran underneath the factory. According to stories, a crazy homeless man used these tunnels to hide and kill his victims. Some variations of the story also claim that the adjoining woods are haunted by the victims while the tunnels are haunted by the disturbed old man.

SHELBY FOREST

Shelby Forest is an unincorporated community located approximately twelve miles from downtown Memphis and eight miles south of Millington, Tennessee. The community sits adjacent to the Meeman-Shelby Forest State Park.

On Epperson Mill Road in Millington, there is a family cemetery, not easily accessible. Neglected by time, what made this graveyard memorable was a certain monument, known to locals as the "Crying Angel." This statue is so well known that the Old Millington Winery named one of their red wines Crying Angel after this bit of local folklore.

The statue gets its name because the angel appeared to be crying real tears. The most logical explanation for this is that the marble from which the monument was carved would absorb moisture and release it through the angel's eyes, giving it the appearance of crying. The monument marked the grave of a young Civil War soldier.

One variation of the story states that the angel is crying for all fallen Civil War soldiers. Another version alleges that a seventeen-

year-old man was killed during the war and buried in his family's cemetery. The angel chosen for his monument was engraved with a curse against the Yankees. Some say that the angel represented the soldier's mother and that she could often be heard crying.

An even more sinister legend stated that the family of the soldier buried a treasure during the war and the Crying Angel would seek revenge on anyone who attempted to retrieve it. Late one night, two men went to the cemetery and dug up the treasure. The next morning, both men were found beheaded in their beds.

According to a 2002 article in the *Daily Helmsman*, after the wings and head broke off the monument, a family member removed the statue from the cemetery, and there have been no further reports of supernatural activity.

Two ghost stories about a lake in Shelby Forest are so similar they most likely originated from the same tale and have diverged as they have been retold. Back in the late 1800s, a married couple lived in a cabin in Shelby Forest, adjacent to a lake. The couple had two children, and the husband was adamant that he did not want any more. Every time the wife gave birth to a new baby, he forced her to drown her newborn in the lake. The cabin is now gone and the lake has since dried, but to this day you can still hear the sound of babies crying by the dried-up lake bed. The area is referred to as the "Valley of the Crying Babies." A similar story involves Lyles Lake, located in nearby Shelby Forest State Park. The lake is so dark that it almost looks black. It is said to be haunted by all the children who drowned there and by Mr. Lyles himself.

In an older section of Shelby Forest there is an old cobblestone road that dead-ends approximately fifty feet into the woods. In theory, if you pull over to the side of the road, a red glowing ball of light with a red eye in its center will meet your car and circle it several times before you can drive off.

Those brave enough to attempt it have found their car unable to start once the red orb appears. Cats and other small pets tagging along in the car have become disturbed and only calm down once they have left the area.

For years, locals have reported a mysterious man who runs up to the cars of young couples parked in the woods and presses his face

against the window. The man was given the nickname "Pig Man" because his face appeared horribly disfigured. Most people believe that he was a resident of Shelby Forest who became disfigured in a mine explosion during the Vietnam War.

Some variations of the story include Pig Man raping and murdering young women parked with their gentleman friends. Those who have had the misfortune of seeing Pig Man claim that he never ages, leading most to believe that he is a ghost. Pig Man can still be seen lurking around Shelby Forest to this day.

Another haunted location in Shelby Forest is the former home of Granderson Glenn, located on Herring Hill Road. Until recently, seven generations of the family had lived in the home for over 150 years.

Granderson Glenn and his wife, Tennysee Carrol Glenn, built the house in 1851. According to the Center for Historic Preservation at Middle Tennessee State University, the couple established the Glenn Farm in 1870. The couple originally owned 500 acres, to which they added 1,500 more. The farm specialized in cotton and corn. The majority of the land has since been sold. Glenn was an officer during the Civil War but was captured and spent most of the war in a Federal prison camp. Glenn died in his home on Christmas Eve 1920.

One former resident of the house, a young mother, heard the sound of bells on the front porch. When she investigated outside, no one was there. Once back inside the home, she found her child's scattered toys lined neatly against the wall.

Workers at the home have also experienced paranormal activity. On one occasion, the ghost of Granderson Glenn was seen sitting in his chair in the attic. At another time, workers heard footsteps walking through the home when nobody else was present.

The home's current owners have experienced doors opening and windows slamming shut. In the former bedroom of Granderson's wife, Tennysee, the owners reported the feeling of being watched and also hearing sounds similar to the rustling of long skirts.

Located on Chaser Road, just off Benjestown Road, the Chase Mansion lies adjacent to the Meeman-Shelby Forest State Park. The home is rumored to have been owned by a rich couple who drove

each other crazy. One evening, the wife became so angry that she killed her husband and chopped his body into several pieces, which she then threw in the nearby Mississippi River. Some say that the couple's ghosts can still be seen walking the mansion's grounds.

The original owner of the estate was William Walter Fisher. In 1939, Fischer purchased four hundred acres of land adjacent to the National Park Service development. Fischer was the president of the Fischer Lime & Cement Company, which was located at 269 Walnut Street, now the current location of Southwest Tennessee Community College's Union Avenue Campus. The company is still in business today.

Before he built the house, Fischer first designed the landscape. His first project was a forty-acre lake. Just past the lake in the center of the lawn, Fisher installed a fountain with colored lights. He then hired architects Schulz & Norton to design the large Tudor mansion. George Madlinger served as landscape architect. The estate also included a wildlife sanctuary. The house was completed in 1941 following two years of construction. In a 1948 interview with the *Commercial Appeal*, Paula Richardson remarked, "No effort was spared, no amount of money seemed too great, no wish for comfort and gracious living too small, to construct a mansion where even royalty would feel perfectly at home."

Fischer died in November 1942 before finishing his plans for the home and grounds. In 1943, the home and four hundred acres were sold to Jamie S. Chase, of Chase Bottling Company, and his wife, Evelyn, for an undisclosed amount (though it was in excess of $100,000).

The Chases spared no expense furnishing their spacious, twenty-room home. For example, the dining room furniture was purchased from the estate of General S.T. Carne. The oversized pieces, such as a carved banquet table for twenty-four people, were too large for the dining room. The Chases simply tore the room down and rebuilt it large enough to accommodate their furniture. Many of the home's furnishings were bought in England. The extravagant chandelier, hanging in the living room, was shipped in twelve boxes, one packed within the other to prevent it from breaking. The house also contained walls lined in walnut, plaster ceilings custom made

for the home and furniture such as a bed slept in by Prince Albert, a table from an English monastery and a gong once used to call English nobility to dinner.

As an aside, Evelyn Chase was the sister of Minnie Brinkley, wife of notorious Dr. John R. Brinkley. Dr. Brinkley is best known for having amassed a fortune by transplanting the sex glands of male goats into men's scrotums in a technique to restore virility. Mr. Chase loaned his in-laws money on more than one occasion and also loaned them bond money after a federal grand jury indicted Dr. Brinkley and his wife on charges of using the United States Postal Service for fraud.

BIBLIOGRAPHY

Adams, Null. "Thousands Buried in Shelby's Field of Unknown Dead." *Commercial Appeal*, October 9, 1931.

Akers, Greg. "Living History: Developer Lauren Crews Plans for the Next Act in the Storied Life of the Marine Hospital and French Fort Area." *Memphis Flyer*, October 23, 2008.

Ashby, Andy. "Stuck with Sterick." *Memphis Business Journal* (October 31, 2008).

Association for the Preservation of Tennessee Antiquities, Memphis Chapter. *Gone But Not Forgotten—19th Century Mourning*. Memphis, TN: Association for the Preservation of Tennessee Antiquities, n.d.

———. *Heritage Houses of Memphis*. Memphis: TN: Association for the Preservation of Tennessee Antiquities, n.d.

———. *James Lee House 690 Adams*. Pamphlet, 1983.

———. *Sixth Annual May "Heritage House Tour."* Brochure, 1966.

Bartholomew, David. "Grace, Grandeur and Ghosts; Memphis' Woodruff-Fontaine House." *Tennessee Conservationist* (November/December).

Bramlett, Sharon. "'Doc' Harris Still 'Heals' the Soul." *Commercial Appeal*, August 13, 1975.

Breese, Dick. "Overton Park Bass Placed in Tri-States." *Memphis Evening Appeal*, October 31, 1932.

Brettman, Allan. "Museum System Plans to Operate Mallory-Neely." *Commercial Appeal*, April 23, 1987.

Brown, Alan. *Ghost Hunters of the South.* Jackson: University Press of Mississippi, 2006.

————. *Haunted Places in the American South.* Jackson: University Press of Mississippi, 2002.

Brown, Charles A. "The Dolls Aren't 'Voodoo,' he said—He Calls Them Symbols of God." *Memphis Press-Scimitar*, July 31, 1961.

Callahan, Jody. "Haunted History Tour Leaves This Dude Cold." *Commercial Appeal*, October 27, 1994.

————. "Legends of Memphis." *Commercial Appeal*, October 31, 1999.

————. "Tennessee Brewery Leaves Potential Untapped." *Commercial Appeal*, August 22, 1995.

Carter, Scott. "Memphis Group Investigates Local Paranormal Events." *Daily Helmsman*, October 11, 2006.

Cashiola, Mary. "The Mystery of the Old Hospital." *Memphis Flyer*, June 26, 2003.

Coffee, Gertha. "Sterick is Considered for Historic Register." *Commercial Appeal*, August 10, 1978.

Cohen, Daniel. *The Ghost of Elvis and Other Celebrity Spirits.* New York: G.P. Putnam's Sons, 1994.

Commercial Appeal. "Catholic Leader Dies at Age 65." June 19, 1959.

————. "Engineer Blames Suffocation for Rainbow Lake Fish Tragedy." August 12, 1934.

————. "Ghost of 1871 May Vanish in Removal of Old Mansion." July 14, 1972.

————. "Historic Home Will Be Restored." July 23, 1967.

————. "Magevney House Open to Public." May 14, 1941.

————. "Memphis Area Deaths." May 8, 1995.

————. "Mystery Envelops Suburban Mansion." September 1, 1989.

————. "Old Family Treasures Found in Repairing Magevney Home." December 5, 1940.

————. "Overton Park Lake Lights to be Used." June 21, 1933.

————. "Owner Contends 'Voodoo Village' Temple of Lord." July 10, 1963.

————. "St. Anne's Mission—Founded in 1910." January 1, 1940.

————. "Sterick Building is Opened to the Public." March 6, 1930.

————. "Suit Follows 'Voodoo Village' Death." December 17, 1970.

————. "Three Youths Charged, Trio Arrested After Incident Near 'Voodoo Village.'" May 16, 1965.

————. "Trustees of Pink Palace Manage Magevney House." July 27, 1973.

————. "12 Deny Charge of Nightriding." July 17, 1963.

————. "25 Years Ago—December 17, 1970." December 17, 1995.

————. "'Voodoo Village' Incident Results in Arrest of 3." May 15, 1965.

————. "Weird Flirtations with Voodoo Mark Beale Street Gold Hunts." March 16, 1947.

————. "W.W. Fischer Estate Bought by J.S. Chase." August 31, 1943.

Coppock, Paul. *Paul R. Coppock's Mid-South.* Vols. 1–4. Edited by Helen M. Coppock and Charles W. Crawford. Memphis: West Tennessee Historical Society, 1985.

————. "They Left Their Architectural Mark on Memphis." *Commercial Appeal*, April 2, 1972.

Cotton, C. Richard. "Couple Live Peacefully With Granderson's Ghost?" *Commercial Appeal*, October 25, 2001.

DAR-SAR-CAR House, Inc. *In the Days of Miss Daisy…100 Years of a Family a House, a City.* Marietta, OH: Richardson Printing Corp, 1975.

————. *The Mallory-Neely House.*

Davie, William S. "Lizzie Davie: The Ghost of Brinkley Female College." West Tennessee Historical Society Papers LII (1999): 16–48.

Dawson, David. "The Ghost in Seat C-5." *Memphis Magazine* (October 1979).

Dedrick, Blair. "Aghast! A Ghost!—According to Folklore Anyway, the Spirit's Haunts Include the Older Sections of Bartlett." *Commercial Appeal*, October 28, 2006.

Dodds, Glenn. Center for Historic Preservation at Middle Tennessee State University. "Glenn Farm." Tennessee Century Farms. http://www.tncenturyfarms.org/shelby_county.

Donahue, Michael. "Long Lost Memphis Artist 'Found' Again by Researcher." *Memphis Press-Scimitar*, July 31, 1980.

Downing, Shirley. "Pipe Bomb Shuts Trails for 6 Hours at Shelby Farms." *Commercial Appeal*, October 7, 1996.

Dries, Bill. "Actor Carved Local Legend—'Sivad' spooked Generation of Kids as Mid-South's 'Monster' of Ceremonies." *Commercial Appeal*, March 25, 2005.

Duggan, Lisa. *Sapphic Slashers: Sex, Violence, and American Modernity.* Durham, NC: Duke University Press, 2000.

Dye, Robert W. *Shelby County.* Charleston, SC: Arcadia Publishing, 2005.

Flemmons, Kenn. *Finest Beer You Ever Tasted.* Little Rock, AR: Goldcrest Holdings, LLC, 2003.

Frank, Ed. "Chickasaw Ordnance Works." The Tennessee Encyclopedia of History and Culture, 2002. http://tennesseeencyclopedia.net/imagegallery.php?EntryID=C077.

Fulbright, Alice. "Museum Life Offers 'Happy Vibes.'" *Commercial Appeal*, April 29, 1976.

Gilkey, Ada. "Charge Against Tate Dismissed." *Memphis Press-Scimitar*, July 31, 1961.

Goodspeed's History of Tennessee from the Earliest Times to the Present, Shelby County, Tennessee. Nashville, TN: Goodspeed Publishing Company, 1887. http://www.tngenweb.org/records/shelby/history/goodspeed/index.html.

Grayson, Anna. "Tales of Ghostly Visits to MCHS Auditorium Abounds." *Commercial Appeal*, April 15, 1998.

Hall, Russell S. *Germantown.* Charleston, SC: Arcadia Publishing, 2003.

Hartz, Jessica. "Haunting Singleton: the Story of Mary." *Bartlett Express*, October 25, 2001.

Hayne, Holli W. "Spill It." *Memphis Flyer*, October 22, 2004.

Holmes, Sara. "Historic Elmwood Cemetery." West Tennessee Historical Society Papers LI (1997): 116–122.

Hulan, Richard H., and Robert C. Giebner. "Written Historical and Descriptive Data, Brinkley Female College (Ghost House)," *Historic American Buildings Survey, National Park Service Department of the Interior*, HABS No. TN-189.

Jordan, Mark. "For Sale?" *Memphis Flyer*, March 9–15, 2000.

Lee, Alton R. *The Bizarre Careers of John R. Brinkley.* Lexington: University Press of Kentucky, 2002.

Lee, Lieutenant George W. *Beale Street Sundown.* New York: House of Field Publishers, 1942.

Magness, Perre. "Brewery Had Heady Times in Heyday." *Commercial Appeal*, February 28, 2002.

———. "City Honors Preservation Efforts." *Commercial Appeal*, May 9, 1991.

———. *Elmwood: In the Shadow of the Elms.* Memphis, TN: Elmwood Cemetery, 2001.

———. "Home's Past Emerges in Restoration." *Commercial Appeal*, August 14, 1997.

———. "Memphis Hosts Several Ghosts." *Commercial Appeal*, October 29, 1987.

———. "Neelys Led Opulent Life on Adams." *Commercial Appeal*, May 16, 2002.

———. "Not All was Easy, Even on Adams." *Commercial Appeal*, May 9, 2002.

Main Street Collierville. *Collierville.* Charleston, SC: Arcadia Publishing, 2007.

———. "A Walking Tour of Historic Collierville." Brochure, available at: http://www.mainstreetcollierville.org/data/233486Outside_000.pdf.

McCaskill, William. "Ghost of Indians' Guardian Dog Still Wails O'er River." *Commercial Appeal*, October 31, 1939.

McCollough, Peggy. "Mary Angela is Tormented by Scofflaws." *Commercial Appeal*, February 27, 1983.

McGuire, Mickey. "Elvis' Ghost Exorcised from Boy's Bedroom." *Weekly World News*, April 26, 1994.

McIlwaine, Shields. *Memphis Down in Dixie.* New York: E.P. Dutton and Company Inc, 1948.

McIntosh Brown, Melissa M. "The Burkle House." *Keystone* (July/ August 1996).

McPeak, Alex. "Former U.S. Marine Hospital One of Many 'Paranormal' Places in Memphis." *Daily Helmsman*, October 29, 2004.

Meanley, Tom. "Vegetable Garden is Admired at the Eugene Magevney Place." *Memphis Press-Scimitar*, May 12, 1943.

Memphis Appeal. "A Woman in White." August 6, 1889.

Memphis Daily Avalanche. "Another and Thrilling Chapter of the Brinkley Female College Ghost Sensation." March 29, 1871.

———. "Brinkley Female College Haunted and in an Uproar of Terror and Confusion." March 5, 1871.

———. Editorial. March 23, 1871.

———. "The Ghost and the Critics." March 11, 1871.

———. "The Ghost Makes a 'Keno.'" March 7, 1871.

———. "Ghost or No Ghost." March 12, 1871.

———. "More About the Ghost that Made a 'Keno.'" March 8, 1871.

Memphis Daily News. "Historic Downtown." June 28, 1983.

Memphis Flyer. "The Persistence of Folklore." February 27, 1997.

———. "Memphis Heritage to Hold Architectural Auction in Old Marine Hospital." September 27, 2007.

Memphis Heritage, Inc. "Historic Beauty on the Bluff." *Downtowner Magazine* (1994).

———. *Overton Park: Vision & Inspiration.* Memphis, TN: Presented by Memphis Brooks Museum of Art, 1989.

Memphis Park Commission and Memphis Museums, Inc. *The Magevney House.* Memphis, TN: Memphis Park Commission and Memphis Museums, Inc., n.d.

Memphis Press-Scimitar. "Century-Old Eugene Magevney Home to be Restored as Memphis Shrine." January 20, 1941.

———. "'Potters' Field' Name Dropped for Burial Plot." April 19, 1934.

———. "Treasures of 100 Years Ago in Magevney Home." May 9, 1941.

———. "'Voo Doo' Man Free on Bond." November 12, 1969.

———. "W.W. Fischer Estate is Sold." August 30, 1943.

Merakis, Lisa. "The Ghost of Elvis Got Me off Drugs." *Weekly World News*, June 23, 1998.

Porteous, Clark. "Of Three Cigars that are 100% Memphis Products." *Memphis Press-Scimitar*, January, 23, 1953.

Potter, Wendell. "Magevney Home on National Register." *Memphis Press-Scimitar*, December 12, 1973.

Price, Charles Edwin. *Haunted Tennessee*. Johnson City, TN: The Overmountain Press, 1995.

Price, Stephen D. "Pain Lingers over Frayser Park Burial Ground." *Commercial Appeal*, August 31, 2000.

Raichelson, Richard M. *Beale Street Talks: A Walking Tour Down the Home of the Blues*. Memphis, TN: Arcadia Records, 1994.

Randall, Nancy R. "Memphis Ghosts Don't Always Wait for Halloween to Make Appearance." *Memphis Daily News*, October 31, 1985.

Richardson, Paula. "Old England is Embodied in its Style." *Commercial Appeal*, November 21, 1948.

Risher, Wayne. "Crowds Get a Jump on Reopening of Lake." *Commercial Appeal*, June 6, 1991.

Roark, Eldon. "Strolling with Eldon Roark." *Memphis Press-Scimitar*, April 28, 1952.

Robertson, J.R. *The Brinkley Female College Ghost Story: The Finding of the Mysterious Jar, its Opening and Contents, A Thrilling Narrative, Based Upon Facts*. Memphis, TN: R.C. Floyd & Co. Printers, 1871.

Saxon, David. "Tiny Cottage, Oldest Building in Memphis, Forms Background in Battle for $3,000,000 in Property." *Memphis Evening Appeal*, December 10, 1931.

Schneider, Albert J, "John Richard Brinkley (1885–1942)," *The Encyclopedia of Arkansas History & Culture*, 2008, *http://www.encyclopediaofarkansas.net/encyclopedia/entry-detail.aspx?entryID=1105.*

Simpson, Teresa R. "Ghosts of Memphis." http://memphis.about.com/od/halloween/p/ghosts.htm.

Sisung, Ryan. "Ghosts Haunting U of M." *Daily Helmsman*, October 31, 2003.

Slusser, Marion. "For 85 Years, Historic Chelsea Avenue Presbyterian Church Has Been and Influential Landmark in N. Memphis Neighborhood." *Memphis Press-Scimitar*, May 31, 1941.

Smith, Jonathan Kennon Thompson. *Bartlett: A Beautiful Tennessee City.* N.p.: self-published, 2001.

Smith, Marshall. "Ruins Hide Ante Bellum Home's Glory." *Memphis Press-Scimitar*, January 24, 1934.

———. "Yankees Turned it into a Stable." *Memphis Press-Scimitar*, January 30, 1934.

Sonsky, Lindsay. "Cielo's a Unique Haunt with Spirit—Karen Carrier's Old Home Brings a Little Bit of Heaven to Adams Avenue." *Commercial Appeal*, August 22, 2004.

St. Anne Catholic Church. *Tasting the Goodness of the Lord.* Memphis, TN: Mercury Printing, 2007.

Stout, Cathryn. "Ghosts of Memphis—The Hunt is on for Creepy Flickers of Light and Things That Go Bump in the Night." *Commercial Appeal*, October 28, 2005.

Sullivan, Erin. "Extended Leake Reunion Reaches Across Time." *Commercial Appeal*, June 6, 2004.

Talley, Robert. "First Catholic Mass in Memphis Was Said in City's Oldest Home—Now Treasured Shrine." *Commercial Appeal*, June 19, 1949.

———. "Ghost Story Stirs Memories; Many Visit Grim Old Mansion." *Commercial Appeal*, October 30, 1939.

———. "Memphis' Greatest Ghost Story." *Commercial Appeal*, October 29, 1939.

———. "Two More Residents Recall 'Ghost' Scare." *Commercial Appeal*, October 31, 1939.

Thomas, William. "Pickings are Skimpy at end of the Rainbow." *Commercial Appeal*, March 26, 1981.

———. "'Voodoo Village' Guards Secret of Master of Strange Kingdom." *Commercial Appeal*, July 14, 1984.

TIME. "Memphis Powder Mill." June 17, 1940.

Tri-State Defender. "Mallory-Neely House Undergoes Restoration." April 25, 1998.

Wallace, Richard. "Pictorial Visit to New Fisher Home at Shelby Forest." *Memphis Press-Scimitar*, January 7, 1941.

Walter, Tom. "Orpheum, Woodruff-Fontaine Ghosts to Haunt Travel Channel." *Commercial Appeal*, June 17, 2004.

Weatherington, Holli. "Stories of Tennessee Ghosts Told Year-round." *Daily Helmsman*, October 1, 2002.

Webb, Arthur L. "Slavehaven Fact or Fantasy?" *Tri-State Defender*, July 12, 2003.

"Weird Travels: Memphis." Travel Channel. Podcast, January 8, 2007, 12:00 a.m. Available at http://www.discovery.com/radio/xml/travelchannel.xml.

We Live Here—In Fear. Episode no. FLWLF-SP01, first broadcast October 27, 2007, by Fine Living Channel.

West Tennessee Historical Society. Historic Marker to Commemorate the Raleigh Sesquicentennial, 1973.

Williams, Larry. "Deputies Check Voodoo Village." *Commercial Appeal*, July 16, 1963.

Wilson, Simone. "Lounging Around." *Memphis Flyer*, July 05, 2007.

Wright, Cecelia Payne. "Treasure Hunters to Descend on Magevney House." *Memphis Press-Scimitar*, October 3, 1981.

Yellin, Emily. "Memphis Journal; Leaving a Little Bit of Elvis Amid an Area Renaissance." *New York Times*, August 7, 2004.

Young, Michael G. "Ghost Stories." *Memphis Magazine* (October 1989).

Other books in the Haunted America series
from The History Press include:

Nashville Ghosts and Legends
Ken Traylor and Delas M. House Jr.
978.1.59629.324.3
6 x 9 • 96pp • $19.99

Haunted Kingsport
Ghosts of Tri-City Tennessee
Pete Dykes
978.1.59629.494.3
6 x 9 • 96pp • $16.99

To purchase, please visit www.historypress.net

HAUNTED AMERICA